THE POCKET

UNIVERSAL
PRINCIPLES
OF ART

© 2018 Quarto Publishing Group USA Inc.

First Published in 2018 by Rockport Publishers, an imprint of The Quarto Group, 100 Cummings Center, Suite 265-D, Beverly, MA 01915, USA. T (978) 282-9590 F (978) 283-2742 QuartoKnows.com

Rockport Publishers titles are also available at discount for retail, wholesale, promotional, and bulk purchase. For details, contact the Special Sales Manager by email at specialsales@quarto.com or by mail at The Quarto Group, Attn: Special Sales Manager, 100 Cummings Center, Suite 265-D, Beverly, MA 01915, USA.

10 9 8 7 6 5 4 3 2

ISBN: 978-1-63159-373-4

Library of Congress Cataloging-in-Publication Data is Available

Cover Design: Coa Design
Page Layout: Barefoot Art and Design
Printed in China

THE POCKET
UNIVERSAL
PRINCIPLES
OF ART

100 Key Concepts for Understanding,
Analyzing, and Practicing Art

John A. Parks

ROCKPORT

Preface

As a professional artist and a teacher of many years at the School of Visual Arts in New York, I sometimes find myself guiding a group of students around a museum.

They are often bewildered.

In the space of a few minutes, we may come across Renaissance angels, fearsome tribal masks, a canvas displaying nothing more than a geometric shape on a white ground, Impressionist views of sunny afternoons, photorealist paintings of Californian diners, and artworks that are simply typewritten sheets of instructions.

How can I begin to explain to my students what these products have in common and how they function as works of art? How can I convey what ideas, techniques, practices, superstitions, stylistic developments, or cultural contexts were in play when they were made? And how can I do it in a way that is simple, direct, and accessible? Then, there is the most mysterious question of all: Why is all this stuff here in the first place? What is it that drives so many people throughout history to keep on making art?

I begin by pointing out the extraordinary fact that every human culture makes art, from the most remote preliterate tribe to the most educated western elites. Clearly, the urge to make art emerges from deep needs and drives in our revolutionary past.

But it has also been taken up by the development of our cultures and transformed into something immensely diverse and complex. This book provides a clear and concise account of how a number of key ideas, techniques, cultural forces, and creative inspirations have combined to bring into being a broad array of artworks. It is the book that I would like to put into my students' hands as they wander through a museum or talk earnestly about art in the studio.

Contents

Introduction

The visual arts are unique in that they form a nexus where craft, technology, philosophy, and the imagination come together to make something that is both wonderful and necessary. This book provides an account of how 100 powerful ideas and principles intersect with the practice of art making. The number, of course, is not definitive, and many more chapters could be included. The ideas presented range from very broad principles, such as harmony or rhythm, to more precise and local ideas, such as Mannerism or Minimalism. I have given a clear and concise presentation of these ideas and have provided for many of them an account of the strategies that artists have used to bring them into play.

The arrangement of the chapters is alphabetical for the purpose of easy access and reference. Most chapters take up two facing pages: One page explains the subject in succinct and straightforward language. The facing page displays illustrations that demonstrate the principle at work.

While I have tried to find examples from as broad a range of art as possible, you will quickly note that they are heavily weighted toward Western art. This is the tradition that has generated the most diverse and active change in recent centuries. The principles, however, apply to all cultures. Indeed, one of the fascinating things about art is that although it emerges from a cultural matrix, it is readily understood across many cultures. French Impressionism is popular in Japan, just as Japanese prints have a ready following in Europe. Tribal art is collected in New York, and Shakespeare is performed in Africa. Art is a universal human utterance, and as we share it around the globe with pleasure and passion, we are all immeasurably enriched.

Abstraction

In abstract or nonrepresentational art, the artwork becomes its own subject.

- In philosophy, abstraction refers to the distancing of an idea from objective referents so that it becomes a distillation of thought. Abstract art came about through a similar process of distancing, as various artists began to present simplified, or distilled, notions of the objective world.

PIONEERS
- Wassily Kandinsky (1866–1944) gradually simplified representational motifs in his work until they became compositions of autonomous floating forms by 1912.

- Jean (Hans) Arp (1866–1966) cut out amorphous forms in wood to make nonobjective sculpted reliefs from 1916 onward.

- Kazimir Malevich (1878–1935), leader of the Russian Suprematist movement, made paintings composed of simple geometric shapes beginning in 1915.

See also Rhythm • Color • Movement • Op Art • Texture

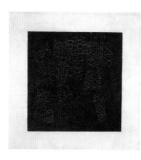

Kazimir Malevich
(1878–1935)
**Black Square on to
White Ground**, 1915.
Oil on linen, 31⅝₆ × 31⅝₆ in
(79.5 × 79.5 cm)

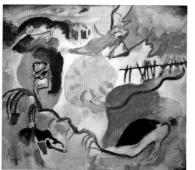

Wassily Kandinsky
(1866–1944)
**Improvisation 27
(Garden of
Love II)**, 1912.
Oil on canvas,
47⅜ × 55 in
(120.3 × 139.7 cm)

*An early abstract work, this painting was shown at the Armory
Show in New York in 1913 where new ideas in European art were
seen in the Americas for the first time.*

Allegory

Allegory is a device whereby abstract ideas can be communicated using images of the concrete world.

- In an allegorical work, elements, whether figures or objects, are endowed with symbolic meaning. Their relationships and interactions combine to create more complex meanings.

- The success of an allegorical work depends on the audience's ability to recognize the identities and corresponding symbolic meanings of each of the elements within the work.

- Part of the pleasure of contemplating such a work involves reflecting on the possible multiplicity of meanings.

Allegory rarely appears in contemporary Western art, no doubt because the moderns, with their interest in abstraction and visual purity, found allegory to be too literary.

See also Symbols

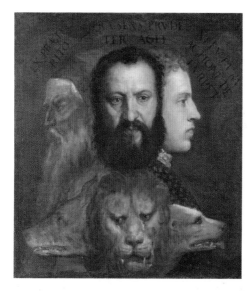

Titian
(c. 1488–1576)
Allegory of Age Governed by Prudence,
1565–70.
Oil on canvas,
30 × 27 in
(76.2 × 68.6 cm)

Here, three human heads represent past, present, and future. They also represent the three ages of man: youth, maturity, and old age. Three animal heads characterize these three ages.

Ambiguity

Sometimes, a work of art acquires strength by projecting a structure or meaning that is ambiguous and open to diverse interpretation.

- **Perceptual ambiguity.** A representation of a three-dimensional formation that can be interpreted in alternative ways. The classic example is the Necker cube, a drawing of a cube that can be seen as occupying space in two alternative ways.

- **Ambiguity of recognition.** A representational element has more than one interpretation due to inadequate or confusing cues. For example, a shadowy shape might be either a human head or an apple.

- **Ambiguity of meaning.** The sense or import of the artwork is ambiguous. The viewer is presented with an ongoing conundrum because symbols, narrative action, or other cues do not coalesce around a clear idea.

See also Perspective • Trompe l'oeil

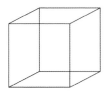
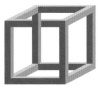

The Necker Cube
The cube can be read as being seen from above or from below. There are insufficient cues to tell the viewer which way is meant.

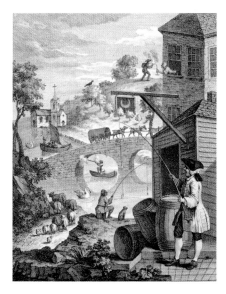

William Hogarth
(1697-1764)
False Perspective,
c. 1750.
Engraving,
8⅛ × 6¹³⁄₁₆ in
(20.6 × 17.3 cm)

The artist plays various amusing games with spatial ambiguity.

004 **Appropriation**

Appropriation is the act of taking work by another artist and presenting it in a new context as original.

- Appropriation highlights the radical idea that art is something whose meaning is as much defined by its context as by anything built into, or contained by, an artwork.

- The process of appropriation and re-presentation is known as recontextualization. It naturally invites questions about the nature of originality, authorship, authenticity, and uniqueness.

- Appropriation is closely related to the art of the readymade but differs because it involves the reuse of a work already intended to be art.

- Many appropriationists have been sued over copyright issues.

See also Conceptual Art • Quoting • Readymades

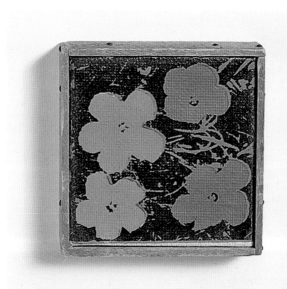

Richard Pettibone (1938–) *Andy Warhol, "Flowers,"* 1964. Acrylic and silkscreen ink on canvas, 8 × 6 in (20.3 × 15.2 cm)

Pettibone has exhibited many miniature versions of famous works of art as his own work.

Areas of Competence

The "area of competence" is the range of usefulness of a particular medium.

- Certain kinds of expression are more suited to one medium than another. For example, silverpoint is perfect for making delicate and precise drawings but is not suited to making powerful expressionist works.

- It follows that the selection of a medium is extremely important. The decision by Edgar Degas (1834–1917) to abandon oil painting and work in pastel enabled him to transfer the fine qualities of his drawing into a colored medium, obtaining results that would have been impossible in oil.

- Sometimes, interesting work emerges from forcing a medium out of its area of competence. When the super-real painters of the 1960s and 1970s used paint to mimic photography, they opened up new possibilities in the art of painting.

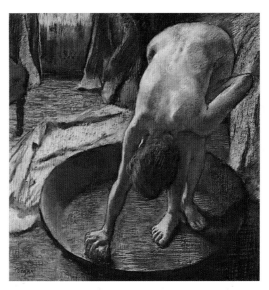

Edgar Degas (1834–1917)
Woman in the Bath, 1886. Pastel on paper, 27 × 27 in (68.6 × 68.6 cm)

The area of competence of pastel is to allow the combination of linear drawing with the layering of rich color. This perfectly suited Degas's abilities and needs.

Authenticity and Outsider Art

Art made outside the cultural mainstream by lone obsessives, or people with psychiatric problems, is deemed by some to have an authenticity that the art of trained practitioners cannot have.

- Interest in such work began in 1922 when Hans Prinzhorn, a German doctor, published the *Artistry of the Insane*, a study of the art of hundreds of mental patients. Such art was later championed by the French artist Jean Dubuffet (1901–1985) who coined the term "Art Brut" to describe it. According to Dubuffet, "Those works created from solitude and from pure and authentic creative impulses—where worries of competition, acclaim and social promotion do not interfere—are . . . more precious than the productions of professionals."

- There is considerable debate as to what constitutes genuine outsider art. In practice, it is hard to be entirely cut off from the cultural mainstream.

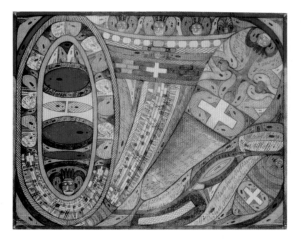

Adolf Wölfli (1864–1930)
003, c. 1930.
Pencil and colored pencil on paper, 19 × 24 in (48 × 61 cm)

Wölfli was abused as a child and grew up to become a psychotic. Held at a German psychiatric hospital for much of his life, he began making art with no training whatsoever. His intense and highly idiosyncratic works eventually gave rise to an epic semi-autobiography comprising over 25,000 pages and some 16,000 illustrations.

Autobiography

When the artist becomes the subject, he assumes control of his public image. In self-portraits, a number of strategies are possible.

- **Introspective.** Truths emerge through the process of observation and reflection.
- **Polemic.** The artist advocates for a social role or position.
- **Narcissistic.** The artist presents an overly self-regarding version of the subject.
- **Narrative.** The artist is presented in a particular environment or situation.
- **Theatrical.** The artist takes on guises, as in the photographs of Cindy Sherman (1954–), where the subject continually assumes new identities.

An extended series of self-portraits can form a broader autobiographical enterprise. Rembrandt (1606–1669) painted himself more than forty times and made more than thirty etchings of his own image, creating a remarkable visual record of the progress of a single life.

See also Conceptual art

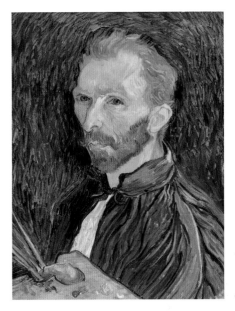

Vincent van Gogh
(1853–1890)
Self-Portrait, 1889.
Oil on canvas,
22 × 17 in
(55.9 × 43.2 cm)

Van Gogh painted himself thirty-seven times, chronicling the drama of his life as well as his stylistic growth from a somewhat clumsy tonal painter to a vibrant and powerful expressionist master.

Balance

In looking at an artwork, the eye assigns varying senses of weight to elements within the composition and enjoys a more satisfactory experience when they seem to be balanced.

When elements are dynamic—that is, they feel as though they are in movement—the eye is more satisfied when their strengths and directions balance out within the composition.

The assignment of weight to a particular element can be affected by the following:

- **Scale.** Larger elements are read as heavier.
- **Color.** Saturated color is usually read as heavier than unsaturated color.
- **Tone.** Darker elements generally feel heavier than lighter elements.
- **Strength of shape.** Angular shapes generally feel heavier than amorphous shapes.

See also Composition • Beauty

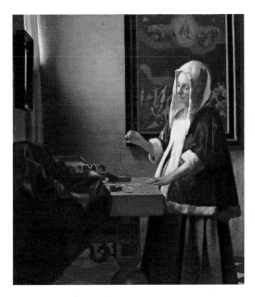

Johannes Vermeer (1632–1675)
Woman Holding a Balance, c. 1664.
Oil on canvas, 15⅝ × 14 in (39.7 × 35.6 cm)

A woman holds a delicate gold balance while the vertical line of the frame behind her exactly bisects the canvas. The painting celebrates balance both in its composition and subject matter.

Beauty

The idea that a work of art should be beautiful is widely held. But just exactly what beauty is has been debated since ancient times.

- **Plato** (427–347 BCE) felt that we perceive an object as beautiful because it partakes of an ideal form of beauty that exists in some sort of higher plane.

- **Aristotle** (384–322 BCE) discussed beauty in his *Metaphysics* and declared that its universal constituents were order, symmetry, and definiteness.

- **Vitruvius** (c. 80–15 BCE) proposed a theory of beauty based on the idea that nature provides in its designs certain proportions that are universally beautiful. He cited the ideal proportions of the human body as the most desirable basis for structuring beautiful buildings and objects.

- **Sigmund Freud** (1856–1939) writes on beauty in *Civilization and Its Discontents*: "All that seems certain is its derivation from the field of sexual feeling."

See also Proportion and Ratio • Balance

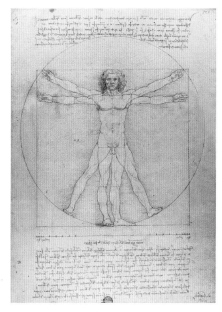

Leonardo da Vinci
(1452–1519)
Vitruvian Man,
c. 1490.
Pen and ink on
paper, 14 × 10 in
(35.6 cm × 25.4 cm)

*Da Vinci was impressed with the rediscovery of the work of
Vitruvius, a Roman architect who advanced the notion that the
human body presented a set of ideal proportions.*

Boundaries

One of the defining characteristics of artworks is that they are separated from the world by an implied or formal boundary.

- This is true in all cultures. It appears that contemplating an artwork requires that we see it as a realm set apart from ordinary life.

- Tribal artworks are usually physical objects or are confined to the objects or structures on which they are painted.

- In Western painting, the picture frame formalizes the separation of the artwork from its surroundings.

- Western sculpture developed the plinth, a formal stage on which the work could be displayed.

- Some modern-era artists sought to blur, or dispense with, the boundaries of artworks. Various kinds of installation art occupy spaces that the audience can walk through, while some performance art seeks to incorporate the audience into the event.

See also Land Art • Conceptual Art

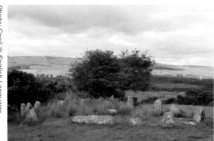

Carrigagulla Stone Circle, Ireland

Many preliterate cultures demarcate boundaries within which religious rites and magical events take place.

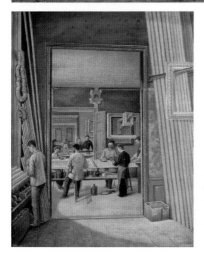

Anonymous Artist
Picture Frame Workshop,
c. 1900.
Oil on canvas,
116¹³⁄₁₆ × 94 in
(296.7 × 238.8 cm)

Brush Techniques

Over the centuries, a wide variety of brush techniques have evolved.

- **Stippling.** Paint is applied in small, even strokes so that tonal and color gradations can be created in a delicately broken surface.

- **Impasto.** Paint is applied in heavy, opaque layers.

- **Scumbling.** Paint is built with an array of open marks pulled over the surface in a loose and uneven way to create a soft, broken, and active layer.

- **Knocking down.** A line or edge of wet paint is softened by pulling the end of a brush through it in a crisscross fashion.

- **Dragging.** A brushstroke pulls one color into another to create an active blend.

- **Dry brush.** Only a small amount of paint is put on the end of the brush, which is then dragged along a surface so that the paint is picked up in a textured fashion.

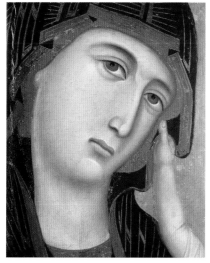

Duccio (1255–1319) **Crevole Madonna**, c. 1280. Tempera on wood, 36 × 23 in (91.4 × 58.4 cm)

A delicate, elongated stippling stroke is used to build subtle tonal transitions across the flesh.

In a dragging stroke, yellow is pulled across a layer of wet blue paint with a stiff bristle brush, creating a lively green.

012 # Chance

Artists are usually interested in control and manipulation, but some have embraced uncertainty for a variety of reasons.

- **Useful accident.** Some techniques, such as heavy impasto painting, continually create many small accidents that the artist can choose to keep or erase.

- **Generating subject matter.** Some modern artists have used chance to select and structure subject matter. Marcel Duchamp (1887–1968), for instance, based the appearance of parts of his *Large Glass* on the chance formations of a falling piece of string.

- **Access to the unconscious.** The Surrealists espoused the idea that inviting chance actions put the artist in touch with the unconscious mind.

- **Conceptual.** Some artists contend that art does not have to be created by an artist but rather is a process that the artist simply mediates. Using chance to create the work removes the artist from the process altogether.

See also Conceptual Art • Process as Meaning

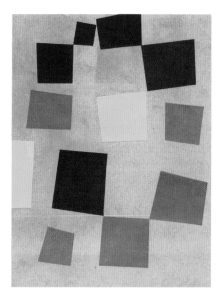

Jean (Hans) Arp (1886–1966)
Squares Arranged according to the Laws of Chance, 1917. Torn and pasted paper, 19⅛ × 13⅝ in (48.6 × 34.6 cm)

The Dadaist artist Jean (Hans) Arp tore up pieces of paper and let them fall onto the floor to create chance compositions.

Classicism and Renaissance

Classicism is a recurring tendency defined by an adherence to certain qualities of Greek and Roman art. These were rediscovered during the Renaissance and continued to reappear in subsequent centuries.

- **Proportions.** Classical artists were interested in certain mathematically derived ratios like the Golden Mean.
- **Clarity.** Aristotle named clarity or definiteness as one of the components of beauty.
- **Restraint.** Classical art prefers stateliness of movement and understatement of drama.
- **Harmony.** Unity of structure was one of the ideals of Classical art. Harmonious proportions, relationships, and color are prized.
- **Idealism.** Platonic idealism—the sense that ideal forms exist elsewhere of which forms in this world are an incomplete reflection—permeates Classical art.

See also Proportion and Ratio • Beauty • Composition

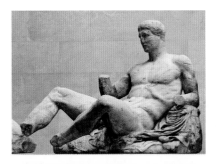

Reclining Dionysos,
from Parthenon
east pediment,
c. 447–433 BCE.

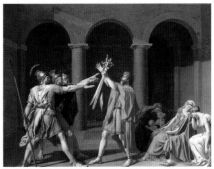

Jaques-Louis
David (1748–1825)
***Oath of the
Horatii***, 1784.
Oil on canvas,
51 × 65⅝ in
(129.5 × 166.7 cm)

*This Neoclassical masterpiece exhibits all the features
of the style: clarity and simplicity of form, orderliness
of composition, and somewhat static action.*

Collage and Assemblage

The construction of pictures from disparate elements, often printed matter or photographs, is known as "collage." In sculpture, the same approach is known as "assemblage."

- Images from disparate sources can be combined to create disjointed and challenging juxtapositions.

- Decorative formations can be made, in which elements are arranged into patterns.

- Photographs and photographic fragments can be combined to create an entirely new scene, an approach known as "photomontage."

- Collage elements can be selected for their adherence to a particular look or vision and then combined. In this case, artists extend their vision through selection.

- The texture of paper and other materials (for instance, crepe paper, foil, tracing paper, or corrugated cardboard) can be important.

See also Areas of Competence

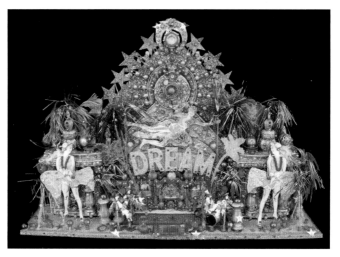

Reginald Case (1937–2009)
Dream, 2006. Assemblage,
17 × 25 × 4 in (43.2 × 63.5 × 10.2 cm)

Case assembles elements that conform to a vision of showbiz glamor.

Color as Light

In the 1870s, a group of French painters dubbed "Impressionists" found a new way to re-create the sensation of light. Up until then, almost all painters had created light by using tonal changes across forms. The Impressionists used small patches of brilliant color, building them into surfaces in which they alternated the color temperature to create a vivid sense of outdoor light.

- Two colors placed close together will give an impression of a third color when seen from a distance.

- Every color in a visual field affects our perception of every other color in the field. Colors are experienced in relation to each other.

- The alternation of color temperature, warm and cool, contributes to the sensation of light.

- It is possible to exaggerate the saturation of color in a visual field to achieve a more powerful experience of light.

See also Color Theory

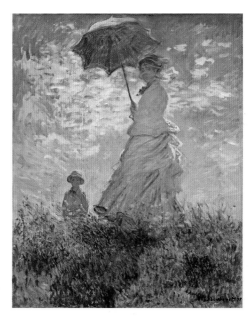

Claude Monet (1840–1926) ***Woman with a Parasol— Madame Monet and Her Son***, 1875. Oil on canvas, 39⅜ × 31⅞ in (100 × 81 cm)

To achieve the vibrant shadow of this backlit figure, Monet paints blues over soft warm browns throughout her costume. The blues alternate between warmer violet and cooler turquoise blues.

Color as Limit

Limiting the color range within a painting can allow the creation of a work that has a distinctive identity, look, feel, or atmosphere.

A limited color range need not preclude representational approaches. Creating an illusion requires that color relationships in a visual field are transferred to the canvas. These relationships can be maintained even when the range of colors is restricted.

Many artists have limited their palettes to achieve a certain look or feel. Rembrandt painted with a palette limited to browns and blacks with an earthy yellow guaranteeing warm harmonies that reinforced the sense of solidity and thoughtfulness in his painting. The English artist Gwen John (1876–1939) worked with a palette of ochres and siennas, with just the occasional use of blue. The resultant close color gives a sense of quiet and reflective calm to the work.

See also Color as Light • Color Theory • Restraint

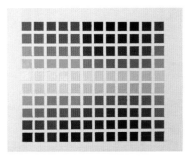

The Zorn Palette.
Anders Zorn (1860–1920) used only four colors: cadmium red medium, yellow ochre, ivory black, and white. Nonetheless, he succeeded in creating a full impression of the world.

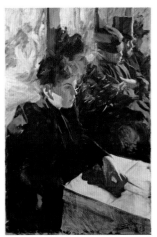

Anders Zorn (1860–1920) *Omnibus*, 1892. Oil on canvas, 39⅛ × 26 in (99.4 × 66 cm)

Color Theory

Color theory offers a conceptual framework for understanding color perception.

In 1839, a standard color wheel was implemented by Michel Eugène Chevreul (1786–1889) in which primary colors stand opposite each other and are known as "complementaries." This relatively crude understanding was superseded by the work of the American scientist Albert Henry Munsell (1858–1918).

Munsell identified three properties of color:

- Lightness (how light or dark a color is)
- Chroma (the amount of color)
- Hue (the position on the color wheel)

To model color relationships, Munsell proposed a sphere in which the hues of the color wheel form the equator. Lightness is represented by the north and south poles, with white at the top and black at the bottom. Chroma is at its maximum at the equator and progressively lessens toward the center of the sphere.

See also Color as Light • Color as Limit

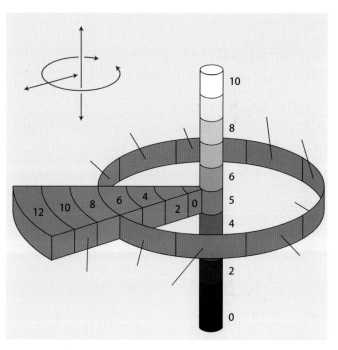

A section of the Munsell Color System. His numbered system allowed for the precise identification of hues, a boon for many industries.

Composition

An image can be considered as a group of distinct elements arranged to further the intentions of the artist.

GEOMETRY
Elements are aligned with an underlying geometric pattern. Some examples include:

- The Golden Mean: A ratio of 1:1.618. Division of a work by this ratio conveys a sense of harmony.

- The Rule of Thirds: Dividing the canvas into three equal lengths both horizontally and vertically.

- Spiral: This technique allows for a sense of upward or downward movement.

DYNAMICS
Compositional elements can possess dynamic qualities. These include weight, a sense of direction, and dominant identity, the idea that certain elements, such as human figures, command more attention than others.

See also Proportion and Ratio

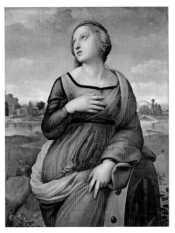

Raphael (1483–1520)
Saint Catherine of Alexandria,
c. 1508. Oil on poplar wood, 28 × 20⅝ in (71.1 × 52.4 cm)

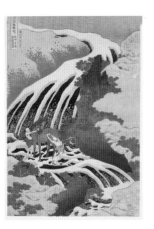

Katsushika Hokusai (1760–1849)
Yoshitsune Falls, 1833.
Ink and color on paper, woodblock print, 13⅝ × 9 in (34.6 × 22.9 cm)

Two artists from different traditions both base their compositions on a spiral. In the Hokusai, the eye moves downward with the flowing water. In the Raphael, the eye moves upward to the heavens.

Conceptual Art

An artwork can be simply an idea or something generated entirely by an idea.

STRATEGIES

- **Imaginary.** The artist supplies a description of a nonexistent artwork.

- **Philosophical examination.** The artist relinquishes the task of making objects in favor of a philosophical examination of art and art practice.

- **Instruction list.** The artist conceives an artwork and provides a list of instructions whereby anyone can fabricate it.

- **Designation.** The artist designates an object or occurrence in the world as an artwork.

- **Document.** An event, object, or activity is documented, and the documentation is then exhibited.

- **Political/social statement.** The artist employs the forum of the art exhibit to focus attention on a political or social issue.

See also Minimalism • Boundaries • Video Art

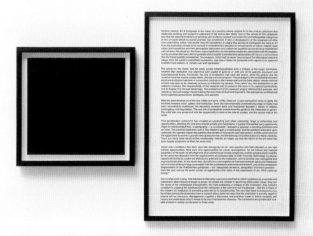

Art & Language
No Secret Painting XI, 2007.
Painting and text: Part 1 (painting), 2 × 2 1/16 in (5.1 × 5.2 cm);
Part 2 (text), 3 × 2 5/8 in (7.6 × 6.7 cm);
Courtesy, Lisson Gallery, London

The artist exhibits a generic painting—a black square—and
hangs next to it a long analysis of various dynamics within
the art world.

Consistency of Visual Language

Consistency of language throughout a work of art is nearly always necessary if it is to be coherent.

- For example, it is hard to make a representational painting read well if half of it is in black and white and the other half in color. Tonal and color structure must be consistent to sustain an illusion.

- The same principle applies to handling. It is nearly impossible, for example, to develop a unified painting in which part of the picture is executed in heavy brushstrokes and the rest of it is painted in very small and delicate brushstrokes.

- The idea that we generally require some form of unity to be present throughout a work of art goes back to Aristotle's *Poetics*. More recently, the writer W. Somerset Maugham (1874–1965) observed, "The essence of the beautiful is unity in variety."

Francis Picabia
(1879–1953)
Idylle, 1927.
Oil on canvas,
44⅝₁₆ x 32½ in
(112.6 x 82.6 cm)

An artist will sometimes break with the idea of consistency
of language for effect. Francis Picabia often combined a
tonal image with a linear drawing to create a kind of two-tier
presentation in his works.

Craft

Craft is the physical skill and expertise developed to perform a particular task.

- From the ancient world onward, art making was inseparable from the mastery of crafts. With the arrival of the Romantic era, there was a growing recognition that art and craft were not synonymous.

- The matter came to a head when the American painter James Whistler (1834–1903) exhibited loosely sketched paintings in the 1870s. The critic John Ruskin (1819–1900) accused him of "flinging a pot of paint in the public's face." Whistler sued and prevailed.

- Ruskin felt that craftsmanship could play an integral role in an ideal society. Inspired by this philosophy, the Arts and Crafts movement was formed, centered on the talents of William Morris (1834-1896). This movement revived traditional crafts and looked to indigenous English folk art, medieval design, and vernacular architecture for inspiration.

- With modernism, craft has become increasingly divorced from the fine arts.

See also Sufficiency of Means

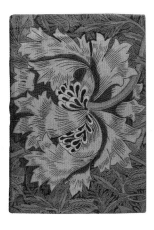

William Morris (1834–1896)
The Golden Legend, 1892.
Woodcut title, 11¹⁵⁄₁₆ × 8⁹⁄₁₆ in
(30.3 × 21.7 cm)

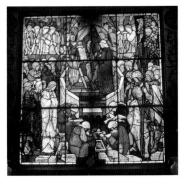

Edward Burne-Jones
(1833–1898)
***David's Charge to
Solomon***, 1882.
Stained glass,
about 80 × 80 in
(203.2 × 203.2 cm)

The Arts and Crafts movement inspired the painter Burne-Jones to engage in traditional crafts such as stained glass.

Creativity

Creativity is the generation of new ideas, insights, and previously unimagined images.

- Creativity is a surprisingly recent idea. Greek philosophy regarded the visual arts as largely imitative. It wasn't until the Renaissance that creation was recognized as a characteristic of human beings and not until the Romantic era that any serious thinking was applied to the function of the imagination.

- The first good attempt at analyzing creativity only appeared in 1926, when Graham Wallas (1858–1932) proposed the following model:

 1. Preparation: An initial assessment of a problem
 2. Incubation: A waiting period while the mind absorbs the task
 3. Intimation: A sense that there is a solution
 4. Illumination: A creative insight occurs
 5. Verification: Examination of the solution's success

- Most accounts of creativity report a role for time away from a problem. Einstein observed, "Creativity is the residue of time wasted."

See also Imagination

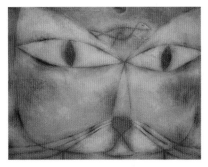

Paul Klee
(1879–1940)
Cat and Bird, 1928.
Oil and ink on
gessoed canvas,
mounted on wood,
15 × 21 in.
(38.1 × 53.3 cm)

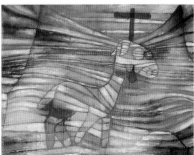

Paul Klee
(1879–1940)
The Lamb, 1920.
Oil and pen and ink
on cardboard,
16 × 12⅜ in
(40.6 × 31.4 cm)

*Klee followed an intuitive path of freely associated imagery,
rich color, and varied handling. A fountain of creativity, he made
more than 9,000 artworks.*

Cross-Cultural Fertilization

Art evolves and changes when the works of one culture become available to another.

- In the 1850s, when Japan was opened to European traders, an influx of Japanese prints and artifacts fueled a revolution in design and painting. Vincent van Gogh was directly influenced by Japanese prints, of which he had a large collection.

- At the close of the nineteenth century, an expanded flow of artifacts from Africa and the Pacific influenced Picasso and many other artists, inspiring a taste for simplified, or even brutal, forms.

- Cross-cultural flow is rarely one-way. Japanese printmaking was heavily influenced by European art in the second half of the nineteenth century. Conventions, such as perspective, were introduced, creating a new hybrid form.

- With the advent of the Internet, hybridization of forms and ideas now happens in a much shorter time frame.

See also Style and Stylishness

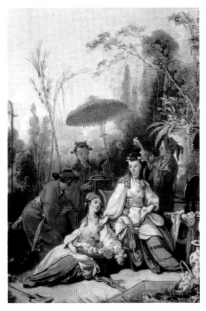

François Boucher
(1703–1770)
The Chinese Garden
(Detail), 1742.
Oil on canvas,
15¹⁵⁄₁₆ × 18⅞ in
(40.5 × 47.9 cm)

In the colonial era, artworks from China and India captivated European artists. François Boucher made designs based on Chinese textiles and paintings during the "chinoiserie" craze of the eighteenth century.

Cubism

Cubism was a movement that emerged in Paris around 1907 and profoundly altered the way artists thought about painting and its ability to represent the world. The Cubists constructed images that combined multiple viewpoints in a shallow picture space. Abandoning perspectival space and continuous description of form, they asserted a new autonomy for painting.

STRATEGIES

- **Simplification.** Subjects are simplified to versions built from straight lines, cubes, circles, or cones.

- **Fracturing.** Outlines of elements are broken up so that only partial views are visible.

- **Shallow planes.** Elements are presented as the edges of planes. The effect suggests a shallow space both in front of and behind the picture plane.

- **Recombination.** Elements are recombined so that multiple viewpoints are melded together to form a single image.

See also　Collage • Movement

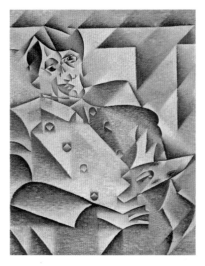

Juan Gris (1887–1927)
Portrait of Pablo Picasso, 1912.
Oil on canvas,
36 × 29 in
(91.4 × 73.7 cm)

The fractured shallow picture plane of Cubist paintings allowed new prominence of textured surfaces and collaged elements.

Dada

In 1916, a group of artists working in Zurich, Switzerland, named themselves by the nonsense word "Dada." Led by the poet Tristan Tzara (1896–1963), they promoted an art of rejection and extreme behavior, using poetry, theater, painting, and sculpture to attack what they saw as the entrenched bourgeois values that had driven Europe into World War I.

STRATEGIES

- **Irrationality.** Poetry, performances, and artworks deliberately undermined common sense.

- **Spontaneity.** Artists embraced spontaneous behavior and extemporaneous outpourings.

- **Novelty.** New experimental forms, such as readymades, photomontage, and multimedia, emerged from a willingness to accept anything as art.

- **Humor.** A sense of the absurd was used to ridicule and undermine prevailing cultural values.

- **Politics.** Artisits embraced communist ideals for ending private property and transferring power to the masses.

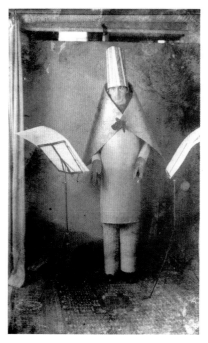

Hugo Ball performing at Café Voltaire

Hugo Ball, a German artist, was one of the founders of Dadaism and was deeply critical of the forces in society that had led to World War I. He gave performances in which he read poetry consisting of non-sensical words.

Decoration

Art that is intended to simply please the eye, to adorn a surface, or to act as ornamentation is generally referred to as "decorative." Most decorative art deploys pattern, a repeated motif that forms a geometric regularity. Decoration can include the following basic pattern types:

- **Grid.** A motif is repeated tile-fashion in horizontal, vertical, or diagonal rows.
- **Repeat.** A motif is designed so that it can repeat, with one side fitting into the other side of its next appearance.
- **Stripes.** Parallel lines are repeated, usually in various colors.
- **Meander.** A single line runs continuously and repeats the same motif: for example, the Greek "key" pattern.
- **Other regularities.** Nature provides examples of patterns formed from spirals, fractals, and near-regularities, such as the cracking induced by shrinkage in mudflats.

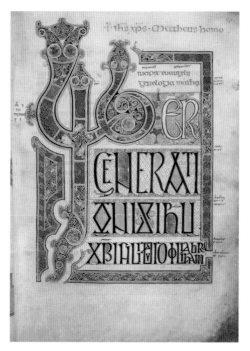

Linsdisfarne Gospels, Saint Matthew, 8th century. Ink, pigments, and gold on vellum

Many medieval manuscripts deploy elaborate decoration to enhance the page and convey a powerful sense of value and devotion.

Distortion

Distorting a form, a face, or space itself is one of the most dramatic and powerful statements an artist can make.

- **Facial distortion.** In much tribal art, images of the human head are subject to gross distortions.

- **Figural distortion.** Byzantine artists routinely elongated figures to create a sense of presence. The Cretan artist El Greco (1541–1614) borrowed from this tradition, bringing the power of elongated forms into Spanish painting with highly expressive effect. The German Expressionist painters of the twentieth century often brutally distorted figures.

- **Spatial distortion.** Perspectival space can be distorted or skewed by adjusting the geometry to create surprising or alarming shifts in space.

- **Distortion as style.** Some artists adopt distortion as an individual style. Columbian artist Fernando Botero (1932–) paints all his figures as though they were enormously fat.

See also Expressionism

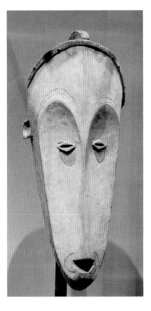

Fang Mask, Gabon, early 20th century. Wood, 26 in (66 cm) high

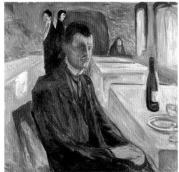

Edvard Munch (1863–1944)
Self-Portrait with a Bottle of Wine, 1906. Oil on canvas, 43⁵⁄₁₆ × 47¼ in (110 × 120 cm)

Munch distorts the perspective so that it closes in on the sitter and is somewhat unstable on the right. A sense of unease is created. The Fang mask grossly elongates a human head.

Distribution

The way in which elements are distributed across a surface is an important consideration in composition.

- This is especially true when elements are small relative to the area of the canvas. They can be clustered or scattered or be concentrated or dispersed. The viewer's eye tends to rush toward concentrations and move more slowly in sparse areas, which makes a wide range of dynamics possible in which the eye is pulled or pushed in various directions.

- Careful control of distribution can confer extra properties on elements in a picture. They can be made to appear "sticky"—to have the tendency to stick together—or they can be made to feel airy and free floating.

- The idea of distribution can be important in organizing the color; the placement and grouping of related colors within a composition can greatly affect their appearance and function.

See also Composition

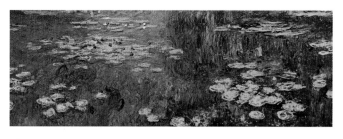

Claude Monet (1840–1926)
Water Lilies, 1920–1926.
Oil on canvas, 86³⁄₁₆ × 237 in (219 × 602 cm)

In this mural, Monet orchestrates the natural distribution of water lilies into clusters, pulling the viewer's eye from one concentration to the next.

Drawing Language

The art of drawing encompasses a complex array of approaches.

- **Simple outline.** A line is drawn around the shape of an object.
- **Contour.** Lines are drawn along the contours of a form, describing the interior in more or less the same way that a contour map operates.
- **Hatching.** Multiple lines are drawn closely together in parallel to create areas of tone. The lines can also be built in a crisscross fashion, a technique called cross-hatching.
- **Contour hatching.** This is a combination of contour drawing and hatching in which contour lines are placed only in the shadows and built into tones.
- **Tone.** Tone is applied to create an illusion of light and darkness.
- **Line and tone.** Linear description can be combined with areas of tone to create a hybrid approach.

See also Tone as Structure • Linear Basics

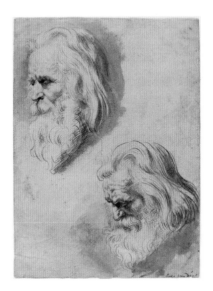

Paulus Pontius (1603–1658) after Sir Peter Paul Rubens
Two Studies of an Elderly Man's Head, 17th century.
Pen and brown ink with brown wash on laid paper,
7⅝ × 5¹¹⁄₁₆ in (19.4 × 14.4 cm)

*The form is laid out with a pen line and the tonal areas are
then established with a wash. In some sections, both contour
hatching and wash are used in combination.*

The Emotive Object

When an artist seeks to create a powerful emotional reaction in the viewer, the enterprise is referred to as "expressionist."

STRATEGIES

- **Exaggeration or distortion.** The artist might elongate, twist, compress, stretch, or otherwise distort the subject.

- **Disturbing subject matter.** This is the depiction of emotionally charged subjects, such as violence, alienation, and sexuality.

- **Heavy line.** A heavy, wide line can carry a sense of weightiness and even brutality.

- **Severe angular shifts.** Acute angular relationships between elements tend to bring about a sense of unease.

- **Strong and unnatural color.** This can provoke a powerful emotional response.

- **Heavy and stressed surfaces.** The surface of the painting or sculpture can be made to feel stressed through heavy impasto, energetic brushing, or the addition of materials to the paint.

See also Expression in the Abstract

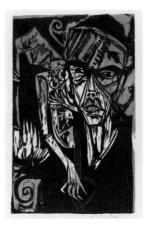

Ernst Ludwig Kirchner (1880–1938)
Qualen der Liebe, 1915.
Color woodcut from two blocks
on wove paper, 13⅟₁₆ × 8⁹⁄₁₆ in
(33.2 × 21.7 cm)

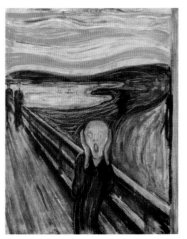

Edvard Munch (1863–1944)
The Scream, 1893.
Oil, tempera, and
pastel on cardboard,
36 × 28⅞ in
(91.4.cm × 73.3.cm)

Munch uses a heavy and brutally insistent line in combination with distorted form and unnatural color to create one of the most famously disturbing images of the modern era.

Erotic Art

An image can be sexually interesting in its own right.

- In post–Roman Western art, there is a history of unease with erotic imagery, attributable to the way in which Christianity sought to control and contain sexual behavior.

- During the Renaissance, sexually explicit images were generally displayed in private. Eroticism was acceptable in publicly displayed imagery relating to the classical past.

- Limiting erotic imagery to classical subjects continued until the nineteenth century and then dissolved. In Paris in 1863, Édouard Manet (1832–1883) painted *Le dejéuner sur i'herbe*, deliberately removing a classical nude from its "safe" setting by surrounding her with men in modern dress. Later, in Vienna, Gustav Klimt (1862–1918) and then Egon Schiele (1890–1918) began to make newly raw and explicit imagery.

- Today, the art world is more tolerant than ever of sexual content.

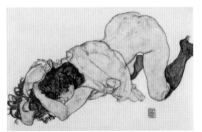

Egon Schiele
(1890–1918)
Kneeling Girl, Resting on Both Elbows, 1917.
Black chalk and gouache on paper,
17⁷⁄₁₆ × 11⁵⁄₁₆ in
(44.3 × 28.7 cm)

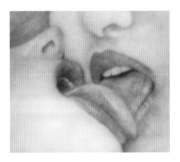

Betty Tompkins (1945–)
Kiss Painting #4, 2012.
Oil on canvas,
60 × 72 in
(152.4 × 182.9 cm)
Courtesy of Gallerie
Radolphe Jansen, Brussels

Schiele's highly charged images of sexual behavior brought a raw, contemporary eroticism into the realm of fine art. Tompkins uses a cool realist approach to embrace commercial erotic imagery as fine art.

Expression in the Abstract

Art can elicit a powerful emotional response from the viewer by using abstract rather than figurative means. Abstract Expressionism, a 1950s American-based art movement, was the first to explore the possibilities of this approach.

- **Mark-making through gesture.** Energetic and dynamic brush marks can record and dramatize the physical gestures used to make them.

- **Scale.** Size and scope can have physical and psychological impact.

- **Texture.** Heavy impasto or the addition of textural materials increases the physical presence of a painting.

- **Color and tone.** Tone and color can be manipulated to achieve disturbing, mysterious, or disquieting effects.

- **Surface tension.** Expressive elements can be composed across a surface so that the entire painting feels taut.

- **Suggestion.** It is possible to deploy abstract elements that suggest representational counterparts.

See also Abstraction • The Emotive Object

Willem de Kooning (1904–1997)
Rosy-Fingered Dawn at Louse Point, 1963.
Oil on canvas, 80 × 70 in (203.2 × 177.8 cm)

_De Kooning uses large-scale brush marks and a heavy impasto
surface to present a composition of considerable power._

Fantasy and Visionary Art

In fantasy art, the artist renders a credible and coherent image of a world that does not exist. Visionary art is a subgenre of fantasy art in which the artist creates images that purport to show divine revelation or apocalyptic scenarios that may have a religious dimension.

- **Anthropomorphism.** Animals and objects take on human characteristics.

- **Otherworldly settings.** Fantasy worlds often feature heightened color, unnatural lighting, and flora and fauna unknown on Earth.

- **Improbable or impossible happenings.** Gravity may be suspended; humans and objects may behave or respond in unnatural ways.

- **Recombination.** Features or denizens of the natural world may be recombined. Fairies, for instance, are miniature humans with wings.

- **Theatrical illumination.** Visionary art, in particular, often makes use of strikingly powerful light sources.

See also Surrealism

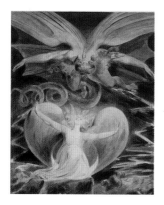

William Blake (1757–1827)
The Great Red Dragon and the Woman Clothed with the Sun,
1805–1810. Watercolor on paper,
15¾ × 12¹³⁄₁₆ in (40 × 32.5 cm)

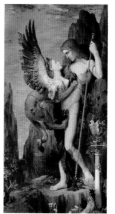

Gustave Moreau (1826–1898)
Oedipus and the Sphinx,
1864. Oil on canvas,
81¼ × 41¼ in
(206.4 × 104.8 cm)

William Blake combined powerful religious feelings with a curiously poetic imagination to create memorable, if sometimes obscure, imagery. Moreau explores purely fantastical imagery loosely based on historical sources.

Finish

"Finish" in art refers to the final polishing-up of a work, especially when it implies the last manipulation to secure a seamless illusion in representational painting. A painting by Jean-Auguste-Dominique Ingres (1780–1867), with its flawlessly executed rendering and fine glazing, would be considered to have "finish." This kind of crafting and its ambition to obtain a dazzling illusion honed to perfection was seen as a highly desirable component of Neoclassical and academic painting in the nineteenth century.

STRATEGIES
- **Fan brush.** Layers of paint are blended with a fan brush to achieve almost photographic smoothness.

- **Glazing.** The painting is built in thin, semitransparent layers, usually over a tonal underpainting. This allows for extremely subtle manipulation of tone and color.

See also Underpainting

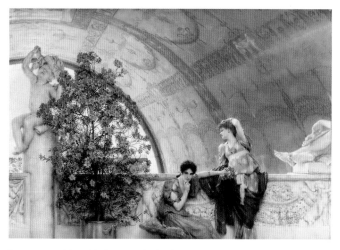

Lawrence Alma-Tadema (1836–1912)

Unconscious Rivals, 1893. Oil on canvas, 17¾ × 24⅝ in (45.1 × 62.5 cm)

Typical of late Victorian English painting, this work combines a highly polished finish with a strong literal narrative.

Formal Innovation

From time to time, an artwork is produced that radically changes the formal means by which art may be made.

- The development of perspectival space in fifteenth-century Italy was an extraordinary formal innovation.

- Caravaggio's development of a newly pungent sense of realism was both shocking and persuasive to his audience at the end of the sixteenth century.

- At the end of the eighteenth century, the Romantics introduced innovations in which spontaneity, open brushing, and highly flexible compositions replaced more stable and calculated approaches to painting.

- With Impressionism in the 1870s, artists discovered a whole new way to re-create a sense of light in painting.

From the late nineteenth century onward, the pace of formal innovation accelerated. Postimpressionism, Symbolism, Fauvism, Cubism, Futurism, Dadaism, Surrealism, and Expressionism each presented new formal innovations all within a space of fifty years.

See also Creativity • Shock

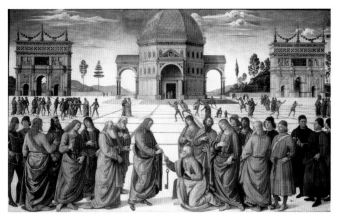

Pietro Perugino (1446–1523)
The Handing of the Keys to Saint Peter, 1481–1483.
Fresco, 11 × 18 ft (3.4 × 5.5 m), Sistine Chapel

*The mastery of perspective was one of the great formal
innovations in Western art, allowing for seamless re-creation
of a three-dimensional world.*

Form Rendered

Rendering three-dimensional forms on a two-dimensional surface is one of the central recurring tasks of representational painting.

STRATEGIES

- **Monochrome underpainting.** Painting an image in a monochrome, usually a muted warm color, allows for adjustment of drawing and tone before the business of color is addressed. The color is applied on top in glazes or with stippling so that a sense of the underpainting is transmitted from beneath.

- **Grayscale and palette control.** The painter lays out a grayscale on the palette and then mixes color in strings or runs, using the grayscale to accurately measure the tonal position of each hue.

- **Finish.** Rendering smooth forms, such as flesh or fabric, can require soft gradations that involve blending painted surfaces. Artists use a fan brush to achieve this, dragging the very top of the paint surface in multiple directions with a light touch.

See also Underpainting • Finish

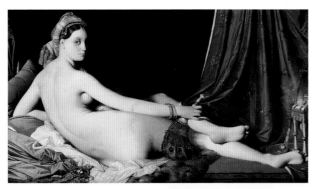

Jean-Auguste-Dominique
Ingres (1780–1867)
Grand Odalisque, 1814. Oil
on canvas,
35¹³⁄₁₆ × 63¾ in (91 × 162 cm)

*Ingres left unfinished this second version of Grand Odalisque,
revealing his underpainting technique. Color would have been
added in glazes on top of this monochrome rendering and the
surface blended with a fan brush.*

Gender

Since the inception of the feminist movement in the 1960s, there has been much discussion about the nature of art made by women and their level of participation in art.

BASIC ISSUES

- Is there a difference between the art made by men and women?

- Given that women have been historically underrepresented in the arts, does this show that a male-dominated culture has consistently discounted the qualities or concerns of women's art? Or does it mean that in their traditional (and biological) roles as mothers, women have not had the time, freedom, and professional access to gain the skills needed to achieve excellence?

- What steps can be taken to increase the representation of women in the arts?

Claudia DeMonte (1947–)
Abundance: Shoes, 2011. Cast bronze,
8½ × 6 in (21.6 × 15.2 cm)

DeMonte addresses issues of female fetish in a playful but direct manner.

Harmony

Harmony is achieved in a work of art when the relationships between its elements are mutually beneficial and aesthetically pleasing.

In music, harmony is a result of certain mathematical relationships between notes. Mathematical relationships can also play a role in visual harmony when variations in shapes, areas, and angles have some sort of mathematical consistency. Similarly, colors that stand in an orderly relationship to each other within a theoretical color solid will tend to feel more harmonious than those in a disorderly relationship. However, perception of color can be influenced by a great many factors, including context, personal association, and minute variations in the color purity of pigments, all of which make a scientific recipe for harmony all but impossible. In the last resort, harmony is an aesthetic response, a judgment of feeling as much as an objective measure.

See also Beauty • Color as Theory

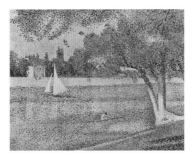

Georges Seurat
(1859–1891)
***The Seine and La
Grande Jatte***, 1888.
Oil on canvas,
25⁹⁄₁₆ × 32⁵⁄₁₆ in
(65 × 82 cm)

Robert Delaunay
(1885–1941)
Nude Woman Reading,
1915.
Oil on canvas,
36¹³⁄₁₆ × 32³⁄₁₆ in
(93.5 × 81.8 cm)

Soft, interlocking shapes form a harmonious grouping.
The color forms a simple harmony in which the major pairs of
complementaries—blue/orange, yellow/violet and red/green—
are balanced.

Hierarchical Proportion

Hierarchical proportion is a convention in representational art in which figures are scaled relative to their importance or social status.

Thus, in Egyptian art, pharaohs are generally shown as larger figures than their surrounding attendants. This convention extended for millennia across much of the world's art, including Mayan, Persian, Indian, Carolingian, and Gothic art. Even in the Sienese painting of Duccio (1255–1319), the central religious figures in compositions are painted on a larger scale than the lower-status attendants.

When perspective arrived in the first part of the fifteenth century, the determination of scale was fixed by the geometry of the setting and new means had to be found to differentiate the status of figures in a composition. Artists quickly developed a vocabulary of placement, lighting, gesture, and clothing to indicate the relative importance of their subjects.

See also Narrative Art • Proportion and Ratio • Perspective

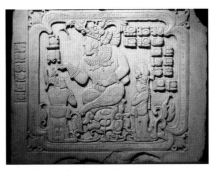

Mayan carving from Cancun showing the ruler Tajal Chan Ahk, 8th century CE

Duccio (1255–1319) **Maestà**, c. 1308-1311. Tempera and gold on panel, 84 × 157 in (213.4 × 398.8 cm)

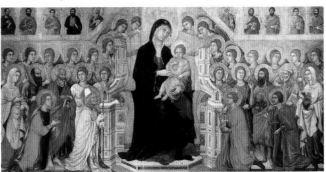

These two works from very different cultures and ages use hierarchical proportion to distinguish between the status of the figures.

Imagination

Imagination is a faculty that allows us to generate mental pictures, ideas, connections, and sensations that may not exist in the world.

The first writer to champion imagination was Samuel Taylor Coleridge (1772–1834). In his *Biographia Literararia*, he observed that imagination not only invents but also combines elements in a way that is coherent and compelling. In other words, he gives to the imagination the creative powers needed to produce works of art: "It dissolves, diffuses, dissipates, in order to re-create; or where this process is rendered impossible, yet still at all events it struggles to idealise and unify. It is essentially vital, even as all objects (as objects) are essentially fixed and dead."

This was radical because it presented the idea, central to the Romantic movement, that art is not generated from nature or artistic precedent, but comes directly from an individual human being.

See also Fantasy and Visionary Art • Creativity • Romanticism

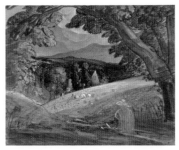

Samuel Palmer (1805–1881) **_Harvesters by Firelight_**, 1830. Pen and black ink with watercolor and gouache on wove paper, 11⁵⁄₁₆ × 14⁷⁄₁₆ in (28.7 × 36.7 cm)

Joseph Mallord William Turner (1775–1851) **_The Evening of the Deluge_**, c. 1843. Oil on canvas, 29¹⁵⁄₁₆ × 29¹⁵⁄₁₆ in (76 × 76 cm)

Both these nineteenth-century artists presented imaginative transformations of landscape in which elements were simplified and then subsumed into an organic and spirited vision.

Installation

Installation art is a genre in which the artist creates a complete or partial environment. As such, it moves away from the traditional concept of sculpture as an object to be contemplated by a viewer.

STRATEGIES

- **Transformation.** A space becomes something else: A gallery becomes a living room, for example.

- **Color.** A space is transformed by color.

- **Lighting.** A space is redefined by controlled lighting.

- **Sound.** Sound can create a powerful sense of place or bring other associations to mind.

- **Video.** Projected images can provide an almost unlimited array of experience and reference.

- **Interactive.** The audience is invited to participate.

- **Space.** Elements are deployed to make palpable or to define a space. One artist has filled rooms with balloons, obliging the viewer to press through the space.

See also Land Art • Video Art • Interactive Art

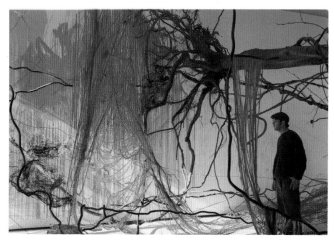

Judy Pfaff (1946–)
Installation at The Rose Gallery, Brandeis University, 1995.
String, tree trunk, tree roots, rope

*Pfaff is a master of using ephemeral materials to make
active, immersive installations, vibrant with color and textural
juxtapositions.*

Intentionality

Intentionality is the idea that a work of art is an expression of an intention on the part of an artist to achieve specific results. For instance, an artist may be intending to create a work that imparts a sense of mystery, or presents an entirely satisfying experience of color harmony, or delivers a highly resolved experience of a set of forms. Whatever the intention, the artist will employ the formal means at his disposal to achieve them. Choices about composition, color, simplification, visual language, and other tools will be aligned in the service of the overall intention.

The antithesis to this point of view is one that holds that artists undergo a process of discovery or exploration in making a work of art and that the resulting artwork emerges with its own authority.

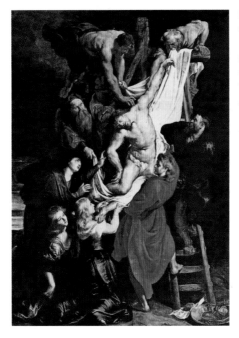

Peter Paul Rubens
(1577–1640)
***The Descent from
the Cross***, 1611–1614.
Oil on panel,
165⅝ × 126 in
(420.7 × 320 cm)

*This large-scale work is designed to elicit a strong emotional
response. To realize his intentions, Rubens uses a composition
with a descending arc and high-contrast lighting to create drama.*

Interactive Art

Interactive art is a genre in which the audience is invited to participate in an artwork, effecting change in its appearance, outcome, and meaning.

STRATEGIES

- **Static input.** The audience is invited to make suggestions to the artist for the progress of an artwork under construction.

- **Physical interaction.** The audience is invited to touch, move, and manipulate a physical object or objects.

- **Co-building.** The audience is invited to contribute to the construction of an artwork.

- **Sensor responsive.** The movements or physical attributes of the audience are picked up by sensors and the data used to affect the appearance or behavior of an artwork.

- **Performance interaction.** Audiences are invited to interact with, or become part of, performance art pieces.

See also Performance Art • Installation • Video Art

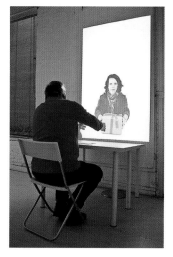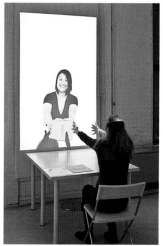

Birthe Blauth (1969–)
The Gift, 2011.
Video projection and computer-operated sensors

A viewer sits at a table and reaches out to take a gift from a figure on a projected video. A movement sensor shifts the video frame so that the figure releases the gift.

Juxtaposition

Juxtaposition is a procedure in which one element is placed next to another, creating a new relationship.

STRATEGIES

- **Subversive.** Expected norms are upended by unlikely combinations of images.

- **Dramatic.** For example, the severed head of John the Baptist held by a delicate Salome.

- **Poetic.** The American artist Joseph Cornell (1903–1972), for instance, juxtaposed images to create a sense of wistful and poetic charm.

- **Polemic.** A political point can be made by juxtaposing one image with another.

- **Positive association.** This is a technique often used in advertising: for example, an athlete might be paired with a beer bottle.

Juxtaposition can also be a purely abstract strategy using shapes, colors, and textures.

See also Surrealism

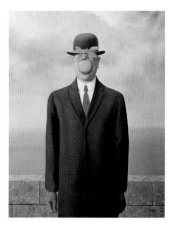

René Magritte
(1898–1967)
*The Son of
Man*, 1964. Oil
on canvas,
45 ⅝ × 35 in
(116 × 89 cm)

*The juxtaposition of an apple and a conservatively dressed
man subverts expectations and invites the viewer to consider
a multiplicity of meanings.*

Kinetic Art

These are artworks that actually move.

- The Russian artist Naum Gabo (1890–1977) is generally credited with making the first kinetic sculpture, *Standing Wave*, in 1920. This consists of a single piece of metal placed vertically and made to oscillate by a mechanism in its base, creating a three-dimensional wave form.

- Alexander Calder (1898–1976) developed a new genre when he invented the mobile. Elements are hung from crossbeams that are balanced so that they move gently with surrounding air currents.

- Swiss artist Jean Tinguely (1925–1991) made sculptures designed to self-destruct. Fabricated from disused machine parts, they had deliberately short lives, suggesting a radical and nihilistic view of the role of art and indeed the nature of life.

New technical options, including servomotors, computerized feedback, and lightweight materials, offer an even wider scope to kinetic artists.

See also Interactive Art • Installation • Movement

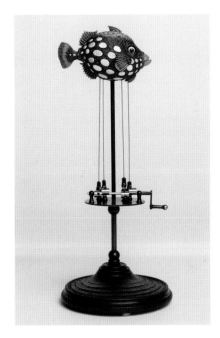

David Beck (1953–)
Trigger Fish, 2002.
Boxwood, mother
of pearl, brass,
8 × 3¼ × 3¼ in
(20.3 × 8.3 × 8.3 cm)

*The American artist David Beck makes small-scale sculptures
whose elaborate mechanics hark back to the clockwork
curiosities of the eighteenth and nineteenth centuries.*

Land Art

Site-specific outdoor art is generally known as land art. Although humans have made outdoor constructions since prehistoric times, the practice of making pure art in this way dates from the late 1960s.

One of the first practitioners was Michael Heizer (1944–), a Californian artist who began to make simple ephemeral works in the desert, often consisting of groups of geometric trenches dug into the desert floor. These would be photographed and the resulting documentation displayed in a gallery or museum. Heizer was quickly joined in this kind of enterprise by Walter De Maria (1935–2013), Robert Smithson (1938–1973), and a host of other artists.

Perhaps the most famous piece of land art is Robert Smithson's *Spiral Jetty* (1970), a structure fabricated using more than 6,000 tons of dirt and rocks on the shore of the Great Salt Lake.

See also Conceptual Art • Minimal Art • Installation

Alastair Noble
(1953–)
***Mapping Arcadia.
Cazenovia and
the Topography of
Place***, 2009.
Flags, string

A contour map of a park is reproduced on the ground using red flags. The artist uses the topography of the place as the subject matter of the piece, reflecting the landscape back on itself.

Layers

One of the principle features of abstract painting vocabulary is layering. Successive applications of paint can be construed by the viewer as elements lying within a shallow depth close to the picture plane.

STRATEGIES

- **Transparency.** Layers of semitransparent paint built on top of one another will create an automatic sense of depth.

- **Color.** By manipulating the color in successive layers of transparent paint, the artist can create rich translucencies that can take on a remarkable feeling of depth.

- **Overlapping.** Elements painted in opaque paint can be overlapped in layers to create a wide range of effects.

- **Mixed media.** Paint can be combined with collaged elements to create a physical layering.

See also Cubism • Expression in the Abstract • Underpainting

Joan Thorne (1943–)
Yangon, 2013. Oil on canvas, 60 × 69 in (152.4 × 175.3 cm)

Transparent and opaque layers impart a sense of shifting depth.
The artist creates different senses of movement for each layer,
delivering a lively pictorial experience.

Linear Basics

Line is a core component of visual thought.

In Western art, various qualities of line are admired, including clarity, precision, stylishness, fluidity, flexibility, and strength.

Line can be used in many ways:

- To create simple divisions
- To construct shapes and designs
- To make letterforms, signs, and symbols
- To suggest form by using varying line weight
- To create dynamic movement by using the "pull" of the line
- To create a sense of expression by exaggerating the weight and movement of the line
- To suggest three-dimensional space
- To create texture
- To transmit the touch of the artist
- To describe form by delineating contours

Eugène Delacroix (1798–1863) **Charioteers**. Pen and black ink with black wash on wove paper, 16⅜ × 14⅝ in (41.1 × 37 cm)

Vincent van Gogh (1853–1890) **Ploughman in the Fields near Arles**, 1888. Reed pen and brown ink over graphite on wove paper, 9¹⁵⁄₁₆ × 13⁷⁄₁₆ in (25.3 × 34.1 cm)

Here, van Gogh uses line in multiple ways. It creates movement, suggests three-dimensional space, and builds textures by massing lines of various qualities.

Mannerism

Mannerism is a style that emerged immediately after the High Renaissance in Italy and lasted from about 1518 to 1580. It was a reaction to the perfection of the High Renaissance style exemplified by Raphael, Leonardo da Vinci, and Michelangelo. Mannerists began to make works dramatizing aspects of classicism in ways that were sometimes surprising and disturbing.

COMPONENTS

- **Distortion.** Forms are often elongated and poses frequently contorted.

- **Precise rendering.** The rendering is usually very careful even when the forms themselves are distorted.

- **Coolness.** Mannerist portraits present people as distant and aloof.

- **Incohesive compositions.** Disjointed compositions make the narrative difficult to ascertain.

- **Flattened space.** Discontinuous space adds to an unsettling perspective.

- **Quoting.** Mannerist painters were fond of quoting other artists.

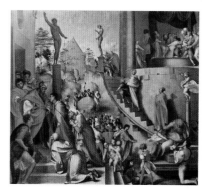

Jacopo Pontormo (1494–1557)
Joseph in Egypt, 1517-1518. Oil on canvas, 17⁵⁄₁₆ × 19⁵⁄₁₆ in (44 × 49 cm)

Agnolo Bronzino (1503–1572)
Venus, Cupid, Folly, and Time [Allegory of the Triumph of Venus], 1540-1545.
Oil on panel,
57½ × 45⅝ in (146 × 116 cm)

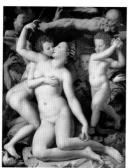

Distortion of some of the figures is combined with highly finished modeling and unnatural gestures to give a curiously artificial quality typical of Mannerism.

Mass

In art, the term "mass" describes a perceived quality of solidity and weight combined with a sense of volume. Rodin's sculpture of Balzac (opposite) depends on the concentrated mass in the upper half combined with the upward lift of the overlarge head. We get an impression of weightiness increasing as we move up the body, so that at last the great forehead and its piercing intelligence take center stage.

In painting, a sense of mass can be increased by a number of devices:

- A low viewpoint tends to increase the sense of scale and weight.
- Powerful contrast and the use of "key" lights can enhance a sense of volume and weight.
- Some colors inherently contribute to a sense of mass: browns, blacks, and deep reds. Lighter colors tend to diminish a sense of mass.

See also Balance

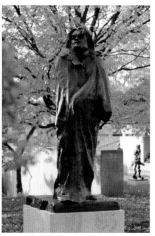

Auguste Rodin (1840–1917) **Monument to Balzac**, 1891–1897. Bronze, 9 ft 3 in × 4 ft × 3 ft 5 in (2.8 × 1.2 × 1 m)

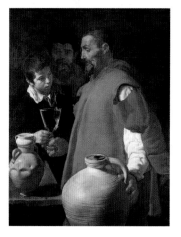

Diego Vélazquez (1599–1660) **Water Seller of Seville**, 1618-1622. Oil on canvas, 41 × 31 in (104.1 × 78.7 cm)

The mass of the glass goblet is the focal point of the painting. Meanwhile, the greater mass of the stone jars is mirrored by the massive solidity of the water seller.

Materials as Art

Art can be generated through engagement with a particular material.

In the late twentieth century, various artists made work whose central feature was the behavior of a medium or material. Thus, Morris Louis (1912–1962) made pictures in which he poured thin layers of paint onto large swaths of unprimed canvas. The resulting paintings are fundamentally demonstrations of how paint behaves, staining and spreading to create soft-edged veils.

Similarly, the gargantuan steel sculptures of Richard Serra (1939–) are dependent on the physical properties of steel. The properties of concrete are central to the sculptures of Rachel Whiteread (1963–), in which its capacities to pour, fill, and harden are used to render palpable interior volumes that are usually filled with air.

In all these approaches, the artwork gains authority by exploring and dramatizing the characteristic behavior and appearance of a medium.

See also Conceptual Art

Liza Lou (1969–)
Kitchen, 1991–1996.
Glass beads

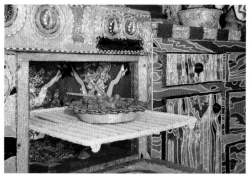

In this life-size kitchen, all the surfaces are created with beadwork, an example of art making driven by a medium.

052 Minimalism

Minimalism was a broad art movement that emerged at the end of the 1950s. Its practitioners sought to strip away traditional endeavors of art such as personal expression, narrative content, aesthetic engagement, compositional hierarchies, and symbolic meaning. Instead, Minimalist artists asserted the primacy of the object itself and the importance of the experience of the object for the viewer unmediated by the artist.

STRATEGIES
- Use of simple geometric shapes or forms
- Use of primary colors
- Use of industrial or non-art materials
- Repetition of elements in rows or grids, avoiding any suggestion of hierarchy, compositional orchestration, or meaning
- Use of techniques that do not display the touch of the individual artist—impersonality is important.

See also Conceptual Art • Materials as Art

Frank Stella (1936–)
Telluride, 1960–1961. Copper paint on canvas,
22½ × 27 in (57.2 × 68.6 cm)

In Stella's painting, a formation of lines set next to each other
make up the painting. This follows Donald Judd's dictum:
"The parts of an artwork should be just one thing after another."

Mixed Media and Multimedia

Modern Western art has embraced many combinations of media. Edgar Degas (1834–1917), for example, combined monoprints with pastel. The twentieth century saw a broadening of this approach. Pablo Picasso (1881–1973) and Georges Braque (1882–1963) combined collage and painting while Paul Klee (1879–1940) often combined pen and ink, watercolor, collage, and oil in the same work. Later in the century, Pop artists Robert Rauschenberg (1925–2008) and Andy Warhol (1928–1987) combined silkscreen images with acrylic paint. Today, the art world will tolerate almost any combination of media.

The term "multimedia" refers to artworks that combine quite disparate disciplines. For instance, a piece might combine handwritten text with video, stereo sound, and various sculptural elements.

See also Installation • Performance Art

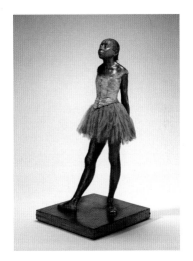

Edgar Degas (1834–1917)
Little Dancer Aged Fourteen, 1878–1881.
Yellow wax, hair, ribbon, linen bodice, satin shoes,
muslin tutu, bronze body, wood base,
38¹⁵⁄₁₆ × 13¹¹⁄₁₆ × 13⅞ in (98.9 × 34.8 × 35.2 cm)

*An early example of mixed media, Degas's sculpture combines
traditional bronze casting with a muslin skirt. The shoes are
made from satin and the bodice from linen.*

Motif

A motif is an element in a composition or design that can be used repeatedly for decorative, structural, or iconographic purposes. It can be representational or abstract and is sometimes endowed with symbolic meaning. Motifs often recur throughout the work of an individual artist.

STRATEGIES

- **Decorative.** The motif as an individual element is repeated to form a decorative whole.

- **Structural.** A motif is repeated within a composition to create or reinforce a stable structure. The Russian artist Wassily Kandinsky (1866–1944) used a variety of abstract motifs, triangles, points, lines, and circles to construct numerous compositions.

- **Symbolic.** A motif is given symbolic significance.

- **Narrative.** A motif is given a particular meaning within a narrative context and then reused to carry the narrative forward.

See also Repetition • Conceptual Art

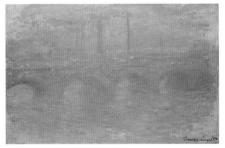

Claude Monet (1840–1926) **Waterloo Bridge, London, at Dusk**, 1904. Oil on canvas, 25⅞ × 40 in (65.7 × 101.6 cm)

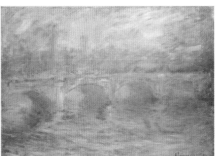

Claude Monet (1840–1926) **Waterloo Bridge, London, at Sunset**, 1904. Oil on canvas, 25¹³⁄₁₆ × 36 in (65.6 × 91.4 cm)

Monet paints the same scene at different times of day. The subject matter becomes a motif through which he explores the effects of varying light conditions.

Movement

Although inherently static, painting and sculpture do sometimes convey a sense of movement.

In the early twentieth century, the Italian Futurists Filippo Marinetti (1876–1944), Gino Severini (1883–1966), Umberto Boccioni (1882–1916), and Giacomo Balla (1871–1958) used stop-motion images to convey motion. They were influenced by the photographs of Eadweard Muybridge (1830–1904), who pioneered stop-motion photographic techniques and made an exhaustive exploration of human and animal movement.

STRATEGIES

• Dynamic movements within the composition

• The depiction of forms or figures that are clearly in motion

• Overlaid or sequential stop-action images

• Rendering photographic effects associated with motion, such as edge-blur, dragged forms, and cropping

See also Kinetic Art

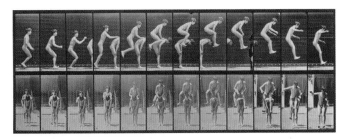

Eadweard Muybridge
(1830–1904)
Boys Playing Leapfrog,
1883–1886. Collotype,
6⅜ × 17 in
(16.2 × 43.1 cm)

Umberto Boccioni
(1882–1916)
Elasticity, 1912.
Oil on canvas,
39⅜ × 39⅜ in (100 × 100 cm)

Muybridge's photographs revolutionized the way people thought about movement. Here, the Italian Futurist Boccioni attempts to describe movement in a city by emulating stop-motion effects.

Narrative

For effective narrative, static mediums must find ways to suggest the passage of time and continuity of action.

STRATEGIES

- **Single scene.** One pivotal moment in the narrative is depicted.

- **Continuous scene.** A narrative continues through various events within a single frame.

- **Multi-scene.** Multiple events are depicted in a single scene, with characters making repeated appearances.

- **Progression in location.** Multiple events take place sequentially at a single location.

- **Sequential framing.** Each event is placed within its own frame, and the frames are arranged in sequence. This is the technique of comic books, manga, and graphic novels.

See also Representation

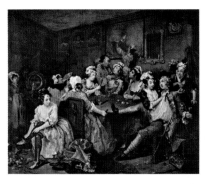

William Hogarth
(1697–1764)
A Rake's Progress,
1732–1735.
Oil on canvas,
24⅝ × 29 in
(62.5 × 73.7 cm)

Apollodorus of Damascus
(50–130 CE)
*Battle against the Dacians.
Retreat by the Dacians into
the Mountains*, Trajan's Column,
113 CE. Bas relief,
Height of base: 5 ft 7 in (1.7 m);
Height of shaft: 88 ft 3 in (26.9 m);
Diameter of shaft: 12 ft (3.7 m)

*The Hogarth shows a single scene in a narrative laid out in a
series of eight paintings. Trajan's Column tells the story of
a military campaign in sequential images spiraling upward
around the column.*

Op Art

"Op art" is a contraction of the term "optical art" and applies to art that creates a perceptual illusion or visual disturbance on the surface of the canvas.

STRATEGIES

- **Linear.** Closely packed lines are arranged in parallel, waves, or zigzags.

- **Perspectival.** Lines or shapes are arranged so that they appear to become three dimensional.

- **Chromatic.** Shapes or lines appear to shimmer or fluctuate when saturated color of similar tonality is juxtaposed.

- **Pattern sequencing.** A motif is progressively altered as it is arranged in a pattern to create an illusion of movement.

- **Moiré.** Three-dimensional grid formations are placed over one another, creating an illusory pattern that shifts as the viewer moves in front of the work.

See also Trompe l'oeil

Bridget Riley (1931–) *Zephyr*, 1976. Acrylic on linen,
88⅜ × 42 in (224.5 × 106.7 cm)

In Brigitte Riley's painting, closely packed wavy lines create
a shimmer that conveys both a sense of movement and an
illusion of rippling space.

Overload

A work of art can sometimes be made more compelling and engaging by increasing the amount and density of information it displays.

Overloading an image, creating a surfeit of incident and interest, can be a spectacular but also a somewhat primitive strategy. Some early northern European art delighted in a great wealth of visual information, packing each part of a composition with dazzling rendering and elaborately crafted detail. Such artworks often suffer from the negative feature of overload—the lack of clarity that results from the absence of a clear hierarchy of importance within the image.

Some contemporary artists have deployed overload as a positive strategy. The quality of surfeit and the sense of claustrophobia that can result take on an expressive role in the work of artists such as Audrey Flack (1931–) or Donald Roller Wilson (1938–).

See also Narrative • Representation

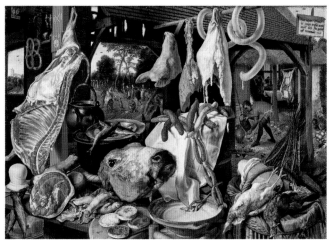

Pieter Aertsen (1508–1575)
Butcher's Stall with the Flight into Egypt, 1551. Oil on wood panel,
48 × 59 in (121.9 × 149.9 cm)

The painting dazzles with a wealth of descriptive detail, but the key narrative, the flight of the Holy Family into Egypt, is all but obliterated by the visual pyrotechnics.

Performance Art

The artist is the focus for live interaction with an audience. The form is extremely open and may incorporate speech, singing, acting, dance, props, multimedia displays, music—in fact, almost anything at all.

STRATEGIES
- **Audience participation.** The artist invites spectators to be part of the performance.

- **Body as medium.** Artists use their own bodies as vehicles.

- **Time extension.** The performance runs for an enormous length of time, ignoring the customary time frame of traditional theater.

- **Disorienting behavior.** The artist behaves in ways that subvert expectations of normalcy.

- **Autobiography.** The artist uses speech, movement, and perhaps multimedia to present an autobiography. The openness of form allows for innovation in storytelling, acting-out, and self-revelation.

See also Dada • Installation

Krzysztof Zarebski (1939–)
BEBECHY, 2012. Performance/installation, Space Womb Gallery, New York (KESHER V Performance Art Event)

Nadja Verena Marcin (1982–)
Zero Gravity, 2013. Video-still of performance, Tampa, Florida

Zarebski mimes eating a fish in a gallery performance. Marcin recites lines from Nietzsche while undergoing zero gravity in a diving aircraft.

Perspective

A convention whereby a 3-D space can be depicted on a flat surface.

A viewer looks at a scene from a fixed point. Between viewer and scene is a defined plane, known as the "picture plane." Rays of light from the scene pass through this plane on their way to the viewer's eye. If their points of passage through the plane are recorded and reproduced, the resultant image is identical to the viewer's experience of the real scene.

- Objects that are more distant will appear to be smaller.

- Objects lying obliquely to the viewing angle will appear to be distorted because they will get smaller in the plane extending away from the viewer but remain stable in the plane standing at right angles to the viewer. This effect is known as "foreshortening."

- Parallel lines not lying in the same plane as the picture will get closer together as they recede and eventually join at a "vanishing point."

See also Representation

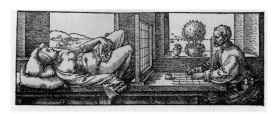

Albrecht Dürer (1471–1528) **Perspective Machine**, 1525.
Woodblock print, 3 × 8⁷⁄₁₆ in (7.6 × 21.4 cm)

*Dürer published several kinds of apparatus for achieving a
correct perspective drawing. Here, the artist holds his eye at
a fixed viewpoint defined by a column. The picture plane is a
wired grid beyond which lies the subject. The artist has drawn a
grid on his paper in the same proportions as that of the picture
plane. He then marks off key points of the subject on his paper
as they appear to him through the grid.*

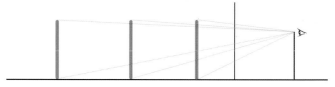

*A viewer (v) observes three poles of identical height—(a), (b),
and (c). As light from each one crosses the picture plane (p),
the pole that is farthest away creates the shortest image.*

Plasticity

Plasticity is the process by which a medium takes on the properties of the substance that it represents.

The most common and effective examples of plasticity occur in painting when the artist manipulates the layering and fluid properties of the paint so that the paint film takes on a flesh-like appearance. This is apparent in many Baroque-era paintings by artists such as Rembrandt, Vélazquez, and Rubens.

Plasticity is not limited to the rendering of flesh; the history of painting is full of examples in which the physical handling of the paint takes on the qualities of such subjects as silk, satin, lacework, masonry, and foliage.

Plasticity differs from the mimicry of trompe l'oeil. With plasticity, viewers are invited to enjoy the spectacle of transmutation, to recognize that they are looking at the subject as built in the medium.

See also Trompe l'oeil

Diego Velázquez (1599–1660)
Portrait of a Buffoon with a Dog (Detail), c. 1650.
Oil on canvas, 55⅞ × 42⅛ in (142 × 107 cm)

The artist uses lively layers of thickly brushed paint to re-create the texture and density of clothing, feathers, fur, and flesh.

Politics and Polemics

Art can sometimes advocate, take a position, or persuade. While political and social issues come and go, some polemical works have endured.

- *The Disasters of War, 1810–1820*. Françesco Goya (1746–1828). (See opposite) This is a suite of etchings that exposes the brutality of war.

- *The Raft of the Medusa*, 1818–1819. Théodore Géricault (1791–1824). (See opposite)

- *The Execution of the Emperor Maximilian*, 1867–1869. Édouard Manet (1832–1883). Manet used flattened space and graphic strength to convey the machinelike brutality of the execution.

- *Guernica*, 1937. Pablo Picasso (1881–1973). Picasso used highly personal vocabulary to protest a bombing.

- *F-111*, 1964. James Rosenquist (1933–2017). Created during the Vietnam War, the 86-foot (26.2 m)–long picture depicts a fighter-bomber juxtaposed with images of consumerism.

See also Semiotics

Françesco Goya
(1746–1828)
Esto es peor,
Plate 37, **The Disasters of War**
series, 1810–1820.
Etching, 9¾ × 13⅜ in
(24.8 × 34 cm)

Théodore Géricault
(1791–1824)
The Raft of the Medusa, 1818–1819.
Oil on canvas,
16 ft 1 in × 23 ft 7 in
(4.9 × 7.2 m)

Géricault's painting reflected public anger at the officers of a French naval ship who abandoned their passengers to a makeshift raft while seizing the lifeboats for themselves.

Prepare and Develop

Many artists engage in planning and developmental stages.

Although approaches can be infinitely various, a number of methods have proved fruitful over the centuries. Ideas can be worked up in rough sketches, drawings, finished drawings, and even full-scale rough versions of the more finished work to come. Problems that can be solved in these stages include the overall conception of the work, the scale and placement of elements, and the tonal and color distribution.

In Italian Renaissance art, cartoons, or full-scale drawings, were used in preparation for frescos and other large-scale works such as tapestries. The use of sketchbooks began almost as soon as paper became available, and they continue to be widely used as a private space where ideas can be explored and problems solved. Sculptors often make preparatory models, called maquettes, for large sculptures.

Jean-Baptiste Carpeaux
(1827–1875)
***Maquette for monument
at Valenciennes***, 1863–1864.
Plaster

John Constable (1776–1837)
Dedham Lock sketch, c. 1819.
Oil on paper laid on canvas,
8 × 10 in (20.3 × 25.4 cm)

*Carpeaux's rough plaster model and Constable's brushy sketch
allow the artists to resolve issues of composition, weight, and
balance before proceeding to a finish.*

Printmaking

Printmaking creates multiple impressions, allowing wider dissemination and lower cost. Since the mid-nineteenth century, artists have numbered and signed their prints, creating limited editions.

PRINCIPLE METHODS

- **Relief.** The artist carves into a surface or "matrix," removing areas that are to remain white in the final image (for example, woodblock and linocut).

- **Intaglio.** The artist cuts into the surface of a metal plate either directly, as in engraving, or indirectly, as in etching where a line is made in a wax ground and then bitten with acid into the metal plate beneath. Mezzotint is a variation of intaglio.

- **Planographic.** The surface of the matrix is changed by the action of chemicals to make parts of it resist inking (for example, lithography).

- **Stencil.** Ink is pressed through a stencil. In silkscreen printing, a fine mesh screen allows ink to be laid smoothly.

Torii Kiyomasu
(c. 1690–1720)
***Kabuki actor Ichikawa
Danjuro in the role
of Takenuki Goro***,
c. 1690s–1710s.
Woodblock print on silk,
21 × 12 in
(53.3 × 30.5 cm)

Jacques Callot (1592–1635)
Franca Trippa and Fritellino,
c. 1622. Etching, 2¹³⁄₁₆ × ⁹⁄₁₆ in
(7.1 × 1.4 cm)

*In Kiyomasu's woodcut, multiple blocks are used to print areas
of color. Callot's etching shows the delicate variation of line
weight characteristic of the medium.*

Process as Meaning

Instead of engaging in complex, intuitive decision-making, some contemporary artists have adopted an approach of simply carrying out a mechanical process. The American painter Jackson Pollock (1912–1956) abandoned his early figurative work to make pictures by swinging paint across large canvases to form long swirling arcs of splattered pigment. The resultant formations derive from the largely serendipitous distribution of the paint.

Making art through process creates artworks that do not carry the traditional baggage of art, the expectation that they hold meaning, convey the intentions of the artist, and provide complex kinds of aesthetic pleasure.

Writing about such works in 1952, the critic Howard Rosenberg observed, "What was to go on the canvas was not a picture but an event . . . The gesture on the canvas was a gesture of liberation from value—political, aesthetic, moral."

See also Conceptual Art • Performance Art

Robert Morris
(1931–)
Untitled, 1973.
Brown felt

Several pieces of felt are draped in sequence over a pole. The form of the work is simply a result of carrying out this process.

Proportion and Ratio

Proportion and ratio are integral to relationships within an artwork and play a vital role in the success of representational constructs.

Proportion is the relationship in size between one element and another, which can be a key factor in conveying a sense of identity to representational elements. The proportions of a human figure, for instance, will have to fall within certain limits to be credible.

A ratio is a mathematical expression of the relationship between one measurement and another. Since the Greek mathematician Euclid (365–300 BCE) cited it, a ratio called "The Golden Mean" has fascinated artists. It is defined as the ratio between two elements in which the proportion of the larger of the two to the sum of the whole is the same as the proportion of the smaller to the larger. This turns out to be an irrational number: 1.618.

See also Perspective • Composition

Schematic of a prayer book page

According to Jan Tschichold (1902–1974) in his *The Form of the Book*, many medieval prayer books used The Golden Mean. Here, the page ratio is 2:3 and the text proportion is The Golden Mean.

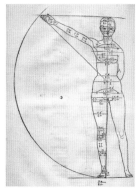

Albrecht Dürer (1471–1528)
Proportions of the Female Body,
c. 1512. Woodblock print,
11⅝₆ × 7¹⁵⁄₁₆ in
(30.3 × 20.2 cm)

Dürer explored many ideas about the proportions of the human body in his 1528 treatise Four Books on Human Proportion.

Quality

When we look at a work of art, we not only experience it but often pass judgment on it. We deem it to be good or bad, better or worse, comparing it favorably or unfavorably to other works of art. We are making a judgement of its quality. The basis on which such a judgment is made can be hard to define and has a strong subjective component. It can shift depending on the understanding and selective framework of the viewer and with the fashions of the day.

What, then, are we doing when we say that one work of art is better than another? Perhaps we are recognizing that some function better than others. They deliver on what they set out to do in ways that are more imaginative, more surprising, and more satisfying.

Paul Gauguin (1848–1903)
Parau na te Varua ino
(***Words of the Devil***), 1892.
Oil on canvas,
36⅛ × 26¹⁵⁄₁₆ in
(91.8 × 68.4 cm)

Paul Sérusier (1864–1927)
Farmhouse at Le Pouldu,
1890. Oil on canvas,
28⅜ × 23⅝ in
(72 × 60 cm)

Over time, a community of taste will coalesce around an assessment of an artwork's or artist's quality. History has judged Gauguin to be a better painter than his contemporary Sérusier.

Quoting

Quoting another work of art can lead to more precise and nuanced meaning as well as richer expression.

- **Ironic.** This is changing the appearance and context of a quoted image to lampoon or otherwise undercut its meaning.

- **Humorous.** The reworking of a famous image, preferably one that has gravity, can be extremely amusing.

- **Subversive.** Using an iconic image in such a way that it subverts the social and political constructs of the day.

- **Supportive.** Quoting another work of art can imply a closeness of intention and spirit with the artist making the quote.

- **Theoretical.** The artist making the quote may wish to explore the way in which the quoted image operates in a contemporary setting. This is part of the strategy of the Appropriationists, a contemporary art movement.

See also Appropriation

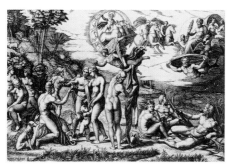

Marcantonio Raimondi (1480–1534), after Raphael ***The Judgment of Paris***, c. 1515. Copper engraving, 11¹¹⁄₁₆ × 17³⁄₁₆ in (29.7 × 43.7 cm)

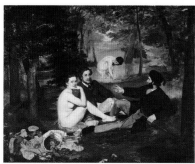

Édouard Manet (1832–1883) ***Le Déjeuner sur l'herbe***, 1862–1863. Oil on canvas, 82 × 104 in (208.3 × 264.2 cm)

The central group in Manet's painting is a quote of an image by Raphael as engraved by Raimondi. The classical image becomes transgressive when it is shifted to modern dress.

Readymades

Although an artwork is usually defined as a product of human agency, some modern artists have contended that any object whatsoever can be presented or designated as a work of art. Such objects are known as "readymades."

The first readymade appeared in 1917, when Marcel Duchamp (1887–1968) famously exhibited, or tried to exhibit, a porcelain urinal as a sculpture. The piece was signed "R. Mutt."

The work was photographed by Alfred Stieglitz and became a cause célèbre when the New York Dadaist magazine *The Blind Man* published an editorial supporting the new art form: "Whether Mr. Mutt made the fountain with his own hands or not has no importance. He CHOSE it. He took an article of life, placed it so that its useful significance disappeared under the new title and point of view—created a new thought for that object."

See also Collage • Conceptual Art

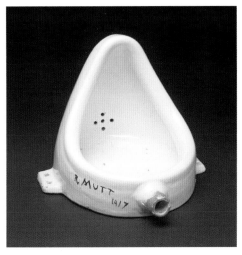

Marcel Duchamp (1887-1968)
***Fountain (replica)**, 1917.
24 × 14 × 19 in (61 × 35.6 × 48.3 cm)

Realism

More than simply representation, realism is the idea that the artwork presents a neutral and inclusive view of the world.

This is an idea that emerges perennially in art. In the late sixteenth century, Caravaggio (1571–1610) shocked and galvanized his viewers by using common people as models and including such realistic details as dirty fingernails and soiled clothing. Realism emerged again in the mid-nineteenth century as a powerful antidote to the foregoing Romantic movement. It emerged once more in the social realism of the 1920s and again with the Super-Realist movement of the 1970s.

The idea that realist art presents a nonselective, non-filtered view of the world is generally deceptive. Choice of viewpoint, subject matter, scale, and medium allow an artist considerable opportunity to manipulate the sense of an image.

See also Representation

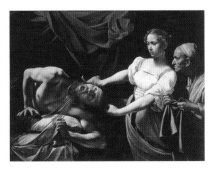

Caravaggio (1571–1610)
Judith Beheading Holofernes,
1598–1599.
Oil on canvas,
57⅛ × 76⅜ in
(145 × 194 cm)

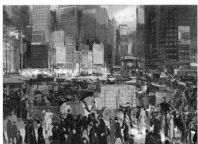

George Bellows
(1882–1925)
New York, 1911.
Oil on canvas,
42 × 60 in
(106.7 × 152.4 cm)

Caravaggio brought graphic realism to his violent subject in the sixteenth century. Bellows brought his experience as a newspaper illustrator to his painting of New York in the twentieth century.

Religiosity

The religious impulse has been the motivating factor for countless works of art.

Most tribal art has a religious or devotional intention, and much ancient art revolves around religious practices. Western art was largely religious until the Renaissance and wasn't dominated by secular art until the nineteenth century. Indeed, one might argue that the respect that is accorded to artworks in the contemporary world is part of the legacy of artworks as a focus of devotion. In some cases, religious images become so closely identified with their subjects that the popular audience has difficulty separating the two.

Religious imagery is often symmetrical. The colossal heads of Easter Island, the crucified Christ, and the myriad statues of the Buddha all exhibit symmetry or near-symmetry. Clearly, humans infer a quality of presence from symmetry that relates to our own symmetrical construction.

Christ the Saviour (Pantokrator),
Saint Catherine's Monastery,
Mount Sinai, 6th century.
Encaustic on panel,
33¹⁄₁₆ × 17⁷⁄₈ in
(84 × 45.4 cm)

Emil Nolde (1867–1956)
The Burial, 1915.
Oil on canvas,
38³⁄₁₆ × 45 in
(97 × 114.3 cm)

*Here the German artist Emil Nolde deploys the newly forged
language of Expressionism to reimagine one of the key scenes
of the New Testament.*

Repetition

Repetition of images can endow them with new authority, visual identity, or meaning.

STRATEGIES

- **Redundancy.** In Andy Warhol's flower paintings, for instance, the repeated image of a desirable object undermines that very desirability, suggesting that it is endlessly available.

- **Decorative.** Repeated images can readily become decorative.

- **Disposability.** Repetition is associated with printing and manufacturing techniques, often carrying a sense of transience, cheapness, and disposability.

- **Breaking the repeat.** Breaking a repeat by introducing variation creates interest by undermining the viewer's expectations.

- **Repetition as power.** The repeated image or element can take on a sense of power or omnipresence.

- **Formal motif.** Repeated images can provide a stable structure to support the exploration of other variables available to the artwork.

See also Composition • Overload

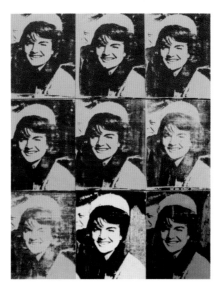

Andy Warhol (1928–1987)
Nine Jackies, 1964. Acrylic and silkscreen on canvas,
65 × 53 × 2 in (165.1 × 134.6 × 5.1 cm)

*This seemingly banal repeat of an image of Jacqueline Kennedy
takes on a portentous quality when we realize the photograph
was taken moments before the president was assassinated.*

Representation

Representation is a convention in art whereby a flat image or a three-dimensional form is understood to stand in for a visual experience of something in the real world.

Translating a visual experience is central to the activity of representational art. The nature of the translation and how it affects the viewers' perception of the subject becomes a powerful way to achieve expression.

Both Aristotle and Plato discussed representation. Aristotle considered it to be natural to human beings and necessary for their comprehension of the world. Plato, on the other hand, asserted that representation involves the creation of illusions that may or may not say truthful things about the world. As such, representations have the capacity to lead the viewer astray. The potential deceptiveness of representation and its ability to mold perception has emerged as a perennial issue in the modern world.

See also Perspective

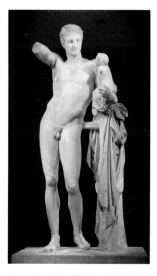

Praxiteles (active 370–330 BCE)
Hermes Carrying the Infant Dionysius,
4th century BCE. Marble,
7 ft (2.1 m) high

Amedeo Modigliani (1884–1920)
Chaim Soutine, 1917. Oil on canvas,
36⅛ × 23 in
(91.8 × 58.4 cm)

*The Greek sculptor's comprehension of the human form
remains a high point in representational art. The modernist
Modigliani returns to more primitive rendering.*

Restraint

Unlike film or illustration, which often seek to entertain and dazzle, fine art can work well when the viewer feels that something is withheld or understated. A sense of mystery can spark the imagination.

STRATEGIES

• Severely pared-down information and stripped-out detail

• A limited palette forcing a few colors to do the work of many can convey a sense of quiet

• Non-showy, quiet execution, such as evenness of brushing and avoidance of bravura technique

• Choice of subject matter that avoids considerable visual drama

• Introduction of deliberate ambiguities by not fully defining elements. Edges may be disguised or missing while shapes are selected that are not readily readable

 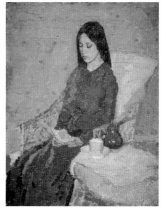

Eugène Carrière (1849–1906)
Alphonse Daudet, 1893.
Lithograph,
15⅝ × 12³⁄₁₆ in (39.7 × 40 cm)

Gwen John (1876–1939)
The Convalescent, 1923–1924.
Oil on canvas,
16 × 13⅝ in (40.6 × 33.8 cm)

Carrière uses soft edges and murky forms to create a suggestive image. John uses a restrained palette and very even execution to project a sense of calm repose.

075 **Rhythm**

Usually a musical concept, rhythm has strong visual counterparts. A sense of dynamic movement working rhythmically across a surface can be compelling on its own or can provide an underpinning for a more complex work. In Michelangelo's *Last Judgment*, for example, the linear organization proceeds in a rhythmic fashion from top to bottom, carrying the viewer's eye downward toward hell.

STRATEGIES

• **Conformation.** A linear rhythmic movement is established and elements within the work are drawn or sculpted to conform to it.

• **Compositional.** Elements are placed so that they set up a sense of rhythm throughout the work.

• **Illusional.** Closely packed formations of lines or shapes can be organized to create an optical illusion of movement or rhythm.

See also Op Art

Melissa Meyer (1947–)
Dassin, 2011. Oil on canvas, 80 × 78 in (203.2 × 198.1 cm)

Rhythmic patterns run through a loosely repeated motif to contribute a lively movement to the image.

Romanticism

Romanticism was a broad intellectual and artistic movement that swept over Europe between the 1770s and the 1850s. It championed an art driven by the emotions and generated from the personality, feelings, and imagination of the artist.

- **Dynamic composition.** Compositions are fluid and dynamic rather than static.

- **Energetic technique.** Romantics used lively, direct brushing and fast execution.

- **Drama.** The artwork featured powerful lighting, strong contrast, and active figures.

- **Nature.** Romantics prized the experience of strong emotions in front of nature.

- **Emotive subject matter.** Subjects that would engage the hearts of the audience were favored.

- **Exoticism.** Romantics sought to escape the then nascent industrialization, with its crowded cities and filthy air, by seeking out distant, exotic settings.

See also Creativity • Imagination

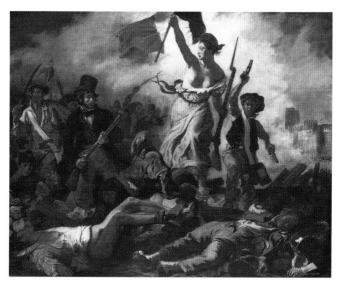

Eugène Delacroix (1798–1863)
Liberty Leading the People, 1830.
Oil on canvas, 102⅜ × 127¹⁵⁄₁₆ in (260 × 325 cm)

With its powerful diagonals, heroic poses, sense of action, and dramatic subject matter complete with corpses and smoke, this work is a quintessential product of the Romantic era.

Scale

The choice of scale can greatly affect the way that a work of art is experienced and the kind of expression available to the artist.

- **Miniature.** Very tiny works can exhibit qualities of compression, delicacy, and intimacy.
- **Small.** Works of a modest scale can readily present the touch of the artist since the scale of mark to that of the whole work is usually fairly large.
- **Medium.** As the size of a work increases, its physical presence becomes more of a factor.
- **Large.** Here, the physical presence of a work can become its most overwhelming feature.
- **Gargantuan.** A number of artists have pushed the idea of scale to improbable boundaries. Robert Smithson's *Spiral Jetty*, a construction on the shores of the Great Salt Lake, involved moving thousands of tons of rock. Here, art intersects with engineering.

See also Land Art

Head of Colossus of Constantine, c. 312 CE. White marble, brick, wood, and gilded bronze, 8.2 feet (2.5 m) in height

Nicholas Hilliard (1547–1619)
Self-Portrait, 1577.
Watercolor on vellum put down on card,
1⅝ in (41 mm) diameter

The Colossus of Constantine *sculpture stood some 40 feet (12.2 m) high, a scale calculated to project imperial power. The Hilliard miniature was intended for intimate delectation.*

Semiotics

Semiotics, or the doctrine of signs, is a branch of modern philosophy that has developed a set of ideas about the nature of meaning and representation. Its principal exponents include Ferdinand de Saussure (1857–1913) and Charles Sanders Peirce (1839–1914).

Semioticians hold that all thought takes place in terms of signs, which may only be interpreted accurately within the broad cultural context in which they are manufactured. They assert that meaning in art is not held within an individual art object but is shared between all the signs and products of a culture. Some philosophers hold that all human intercourse is simply the exchange of signs within a culturally determined system. According to Jacques Derrida (1930–2004), "There is nothing outside the text."

David Teniers the Younger (1610–1690)
Two Peasants with a Glass of Wine,
c. 1645. Oil on panel, 9⅛ × 7⅛ in
(23.2 × 18.1 cm)

Semiotics 2: Deconstruction

Semiotics has provided a critical tool known as "deconstruction." In this process, a critic analyses the signs present within a work of art and exposes the meanings implicit in their relationships.

Osias Beert the Elder
(c. 1580–1624)
***Dishes with Oysters,
Fruit, and Wine***,
c. 1620–1625. Oil on panel,
20³⁄₁₆ × 28⅞ in
(51.3 × 73.3 cm)

In these two seventeenth-century paintings, a glass of wine is presented in different contexts and therefore takes on different meanings. In the Teniers, it is an agent of inebriation. In the Beert, it is an accessory of the good life.

080 **Sensitivity and Sensibility**

One of the most powerful things that art can do is to communicate sensitivity. The artist awakens the viewer to fine distinctions in the perception of various features of the world. These can include color, texture, line, tone, touch, and atmosphere. For instance, Jean-Auguste-Dominique Ingres's graphite drawings are exquisitely sensitive to nuances of shape and form and also display a great sensitivity to more narrative qualities, such as carriage, posture, and character. In looking at such works, the viewer shares in a state of heightened sensitivity.

"Sensibility," on the other hand, refers to that quality in an individual that allows him or her to respond with feeling to people, the world, or works of art. An artistic sensibility is a quality that allows you to appreciate works of art and perhaps to make them.

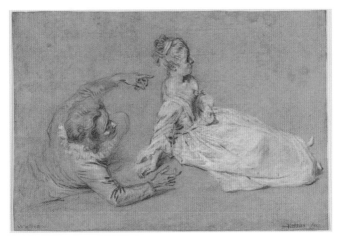

Antoine Watteau (1684–1721)
A Man Reclining and a Woman Seated on the Ground, c. 1716.
Red, black, and white chalk on brown laid paper,
9½ × 14⅛ in (24.1 × 35.9 cm)

*Watteau's drawing displays exquisite sensitivity to line and
touch, using chalk with delicacy and liveliness. He is also
supremely alert to the nuance of posture and gesture.*

Shape

A shape is a formation of edges that is perceived as an individual element. It is in our makeup to apply powers of recognition to shapes. We are prone to find shapes that have meaning to us, such as faces, figures, and animals. We are also sensitive to geometric formations and regularities.

- **Silhouette.** The subject is presented as a flat monochrome shape on a clear background.

- **Abstraction.** Compositions of shapes allow for paintings that explore the formal properties of shape and color or venture into various areas of expression.

- **Formal minimalism.** Some minimalists have composed works with a single shape. The completeness of a single shape, the idea that it is simply a single thought, gives such work an intriguing authority.

- **Decorative.** Repeated shapes can provide pleasing and engaging decorative designs.

See also Abstraction • Minimalism • Proportion

Unknown artist
Goethe Facing a Grave Monument, 1780.
Cut paper,
9¹³⁄₁₆ × 6¹¹⁄₁₆ in (25 × 17 cm)

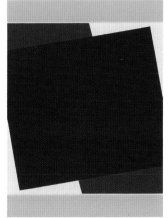

Don Voisine (1952–)
Tilt, 2013.
Oil on wood panel,
16 × 12 in (40.6 × 30.5)

Silhouette relies on the viewer's powers of shape recognition. Voisine's painting explores the dynamics of a group of geometric shapes.

082 Shock

One of the potential strengths of a work of art is its power to shock, a feat that is usually accomplished by flouting a social convention or breaking a taboo. The artwork transgresses the cultural norms of the community or culture in which it is made and therefore faces ostracism. It may go on to garner support; in which case, it will have functioned to shift the culture's conception of what is acceptable to its members. Otherwise, it will be consigned to oblivion. Shock art has the added potential of making the artist notorious and sometimes very famous.

A classic example is Manet's *Olympia*, of 1863, a nude portrait of a well-known courtesan. Here, Manet was exposing the mores of the wealthy, removing the scrim that polite society placed between itself and its vices.

See also Semiotics

Andres Serrano (1950–)
Piss Christ, 1987. Cibachrome print mounted on Plexiglas,
40 × 37¾ in (101.6 × 95.9 cm)

*This photograph of a plastic crucifix submerged in the artist's
urine appeared at the Sensation exhibition at the Brooklyn
Museum in 1999. The show elicited a lawsuit from the mayor
of New York.*

Simplification

Simplifying form is one of the foundational strategies of art. Ancient civilizations generally rendered figures and settings as simplified formations. More sophisticated simplification occurred in the Renaissance, as in the work of Piero della Francesca (c. 1416–1492), whose interest in Euclidean geometry led him to reduce forms toward the condition of geometric solids. Much modern art involves the reduction of appearances to sets of simple forms.

FOUR STAGES OF SIMPLIFICATION
1. **Objective.** The subject is examined carefully.

2. **Analytic.** The central and distinguishing features of the subject are identified.

3. **Reductive.** Extraneous, unnecessary, confusing, and distracting information is stripped away.

4. **Synthetic.** The remaining information is combined to make a new image that exhibits clarity and coherence.

Cycladic female figurine, c. 2300 BCE. Marble, 6¹³⁄₁₆ in (17.3 cm) high

Piero della Francesca (c. 1416–1492) **The Baptism of Christ**, c. 1448-1450. Tempera on panel, 65¾ × 45¹¹⁄₁₆ in (167 × 116 cm)

The Cycladic figurine simplifies the human figure to a near abstraction. Piero simplified his forms to achieve geometric clarity.

Space and Volume

The control of space and volume is central to much Western art. The idea that space can be manipulated so that its presence and shape become expressive is seen in the art of sculptors as diverse as Michelangelo (1475–1564) and Alberto Giacometti (1901–1966).

Because volume and space are invisible, we comprehend them through the arrangement of surfaces, points, and colors. The artist manipulates these elements to control the viewer's experience of space.

In sculpture, Renaissance artists strove to achieve an apprehension of clarity in volume and space while understanding some of the expressive possibilities inherent in controlling these elements. Modern sculptors, freed from naturalistic description, have been adventurous in exploring these possibilities. Space can feel squeezed, open-ended, curved, structured, oppressive, vast, or indeterminate.

See also Mass

Ely Cathedral (Interior), Cambridgeshire, England

Giovanni Paolo Panini (1691–1765)
Interior of the Pantheon, Rome, c. 1734.
Oil on canvas,
50⅜ × 39 in (128 × 99 cm)

The interior space of Ely Cathedral is designed to move the viewer's eye upward, creating a sense of awe and wonder. The painter Panini distorts the perspective to heighten the sense of space.

Spectacle

Art can become spectacle when it seeks to bedazzle, entertain, or overwhelm the viewer. This has often been the province of religious art; mosques, Indian temples, and Western churches are often adorned with decorative or narrative imagery, amassed and displayed in a way intended to dazzle its audience. This kind of theatricality reached a zenith in Europe during the Counter-Reformation, when the Catholic Church instituted a policy of using alluring decorative schemes to attract and maintain its congregation.

In recent years, new endeavors in installation and land art and new technical possibilities in multimedia have spawned a greater interest in spectacle.

The problem with spectacle as art is that its impression on the audience is all too often very short-lived. Viewers quickly become acclimated to glitz and splendor and will look for more lasting interest elsewhere.

Jeff Koons (1955–)
Puppy, 1992. Installed at the Guggenheim Museum,
Bilbao, Spain. Stainless steel, soil, geotextile fabric, internal
irrigation system, and live flowering plants, 486 x 486 x 265 in
(1234 x 1234 x 650 cm)

*Large-scale sculptures, such as Puppy, a giant steel framework
festooned with thousands of flowers, are designed to engage
and overwhelm the immediate attention of the viewer.*

Style and Stylishness

In the art world, "style" essentially means "in the manner of," and applies to the characteristic look and feel of the work of a particular artist or era. For instance, we talk about "Louis XVI style," meaning the look and feel of that monarch's era. Or we can talk about the style of Rembrandt, meaning the look and feel of that master's work.

The emergence of styles in art seems to be a natural result of artists working at the same time, in the same geographic area, and with similar influences and ideas. Styles continually change and mutate as new ideas, concerns, looks, and features are invented, rejected, or embraced.

"Stylish" has a narrower meaning. A work of art is said to be stylish when it exhibits a fashionable elegance delivered with a seemingly effortless surety and aplomb.

Antoine Bourdelle (1861–1929)
The Meditation of Apollo and the Nine Muses, 1910–1912.
Bas-relief, 11 ft 6 in × 49 ft 10 in (3.5 × 15.2 m)

Aubrey Beardsley
(1872–1898)
Salome and John, 1892.
Pen and ink on paper,
8¹³⁄₁₆ × 6³⁄₁₆ in
(22.3 × 15.7 cm)

The Bourdelle is an example of Art Deco, a style prevalent in the 1920s and '30s. The Beardsley is an example of Art Nouveau, a style that flourished at the end of the nineteenth century.

Successive Approximation

Successive approximation is a process whereby the artist makes statements that he or she then continually corrects, gradually arriving at a finished statement. The work alternates between creative generation and critical assessment. It proceeds as both a response to the subject and a response to what has already been achieved in the work.

Prior to the late nineteenth century, artists concealed the process of successive approximation in their finished work. The idea that a work of art could incorporate the record of these changes gradually took hold during Impressionism, with its immediate and fresh technique. The Post-Impressionists took things further. In the mature work of Paul Cézanne (1839–1906), the artist made numerous attempts to record on canvas his shifting perceptions of the locations of the elements in the scene in front of him. The painting became the sum of his attempted approximations.

See also Process as Meaning

Paul Cézanne (1839–1906)
At the Water's Edge, c. 1890.
Oil on canvas, 28¾ × 36⁷⁄₁₆ in (73 × 92.6 cm)

For Cézanne, the finished painting was the aftermath of a process of looking at the subject during which he tried to continually approximate the position of various elements.

Sufficiency of Means

Sufficiency of means is the idea that a work of art is strongest when it achieves its desired result in the most economical fashion possible. Each component, whether it be color, line, layering, or tone, is deployed in a fashion that allows it to achieve its task and no more. Often, this idea involves considerable editing, the removal of extraneous material not necessary for the success of the artwork.

This principle is sometimes expressed by the idea "less is more," a phrase first coined by the English poet Robert Browning in his poem about the Renaissance painter Andrea del Sarto (1486–1530). An opposite outlook can be seen in the so-called "pompier style" academic paintings of nineteenth-century France, where painters such as William-Adophe Bouguereau (1825–1905) indulged in a surfeit of descriptive drama and showy illusionism to the detriment of their paintings.

See also Restraint • Overload

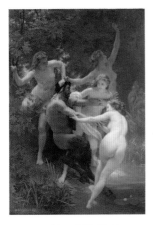

William-Adolphe Bouguereau (1825–1905) **Nymphs and Satyr**, 1873. Oil on canvas, 102⅜ × 70⅞ in (260 × 180 cm)

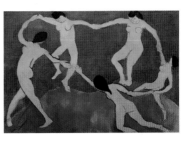

Henri Matisse (1869–1954) **La Danse**, 1909. Oil on canvas, 102¼ × 153⁹⁄₁₆ in (259.7 × 390 cm)

These two paintings address similar subject matter in very different ways. The Bouguereau is tediously rendered and over-described, while the Matisse brilliantly reduces the subject to its essence.

Surrealism

Surrealism, a European art movement that developed in the years after World War I, asserted that the unconscious, nonrational mind was the appropriate guiding force in art. The movement's leader, André Breton (1896–1966), was inspired in part by Sigmund Freud who regarded the dream as a means of access to the subconscious.

STRATEGIES

- **Automatic drawing.** The artist puts himself into a passive trance and allows his hand to move without control on the paper.

- **Frottage.** A sheet of paper is placed over a textured surface and a rubbing made. The artist allows the resultant formation to suggest new imagery.

- **Decalcomania.** Paint is built up on paper and then pressed onto canvas. The paper is removed, leaving often surprising formations. The artist develops images suggested by this chance display.

- **Juxtaposition.** Disparate images yield subversive and poetic meanings.

See also Juxtaposition

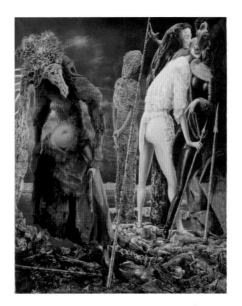

Max Ernst (1891–1976)
The Antipape, 1941–1942. Oil on canvas,
63¼ × 50 in (160.7 × 127 cm)

*Ernst began many of his works with decalcomania, chance
formations of paint, which he developed into unlikely and
yet strangely coherent worlds.*

Symbols

A symbol is a visual element that stands for something else. It may depict the thing that it represents, but this is not a requirement. It is merely necessary that there is an understanding within the culture in which it is produced as to the meaning of the symbol.

In the visual arts, the manipulation of symbols allows artists to convey meaning in many ways. Symbols are sometimes placed within otherwise descriptive or narrative paintings to clarify and reinforce their meaning.

When a painting functions primarily as an interplay between various symbolic elements, it is known as an allegory.

See also Allegory

Hans Holbein the Younger
(c. 1497–1543)
The Ambassadors, 1533. Oil on oak,
81½ × 82½ in (207 × 209.6 cm)

Holbein used still-life elements as symbols in this double portrait.

Symmetry

Symmetry is a quality of ideal balance, where each half of a picture or sculpture is a perfect mirror image of the other. In art, symmetry is generally around a vertical axis, an arrangement known as "bilateral symmetry."

Symmetrical images convey a sense of frontality and stability and can be powerful in creating a sense of presence. This quality has been used over the millennia in religious art.

The downside of symmetry is that its very stability can render it dull. This makes near-symmetry an attractive option: The eye is interested in images that promise symmetry but then deliver subtle differences between the two sides.

See also Balance • Religiosity

The Taj Mahal, 1632–1653.

The Taj Mahal is an architectural essay in quiet presence based on exact symmetry.

Temporary Art

Artists have often made temporary or occasional pieces, but some contemporary artists have focused on works designed to change, decay, or collapse altogether in relatively short periods of time.

STRATEGIES

- **Natural decay.** Dieter Roth (1930–1998) made a number of biodegradable sculptures using foodstuffs.

- **Time limit required by location.** Christo (1935–) and his wife, Jeanne-Claude (1935–), made many site-specific works that were announced to run for a limited period.

- **Obliteration by natural environment.** Richard Long (1945–) has made many pieces out of local materials, piles of stones, and shapes drawn into the earth that will have a relatively short life before being subsumed by the environment.

- **Self-destruction.** Jean Tinguely (1925–1991) made kinetic sculptures that physically destroyed themselves.

See also Conceptual • Land Art • Kinetic Art

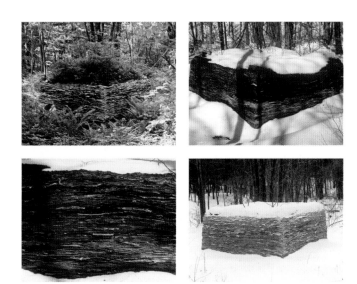

Steven Siegel (1953–)
New Geology #2, 1992. Newsprint, 5 × 10 × 10 ft (1.5 × 3 × 3 m)

The artist amasses a simple and massive geometric form from layered newspapers. The sculpture then decays over a number of years and is subsumed into the natural environment.

093 **Texture**

Both sculpture and painting allow for the creation of texture. In addition, painting allows for the depiction of textures. The sensual excitement afforded by texture is increased by the presence of multiple textures.

Sculpture readily offers opportunities for creating texture. David Smith (1906–1965), for example, often used a handheld grinder to create a dramatic texture on his steel sculptures.

Prior to the late nineteenth century, the prevailing convention in Western art was to make paintings with smooth surfaces. Many artists, however, embraced texture as a subject, incorporating collage into their work.

Since Impressionism, many painters have embraced textured surfaces using thick paint that can be combed, scraped, and even carved. Modern paint technology allows for surfaces from metallic to fiborous. Some painters also use collaged elements to create more substantially textured surfaces.

François Boucher (1703–1770)
Toilet of Venus, 1751.
Oil on canvas, 42⅝ × 33½ in (108.3 × 85.1 cm)

Boucher fills his canvas with depictions of various textures, silk, satin, gold, flesh, and features.

Theme

A theme is an overall idea that carries through a work or series of works. The expression and elaboration of the theme may be the primary goal of the artist or themes may emerge as the artist pursues other ideas.

- **Philosophical.** The artist pursues a theme to convey an idea. For instance, in *The Disasters of War*, a series of etchings by Goya (1746– 1828), the artist pursues the theme of the senselessness of violence in war.

- **Abstract.** A visual idea is explored over a number of works. Robert Motherwell's (1915-1991) series of paintings, *Elegy to the Spanish Republic*, develops variations on a particular abstract formation.

- **Narrative.** A series of works forms a narrative that displays a theme and variations. Giovanni Domenico Tiepolo (1727–1804) produced a long series of pen and ink drawings on the theme of Punchinello, a clownish, stock character in the *commedia dell'Arte.*

See also Narrative • Motif

Giovanni Domenico Tiepolo (1727–1804) *Frontispiece*, c. 1797.
Pen and ink with wash on paper, 16 × 11½ in (40.6 cm × 29.2 cm)

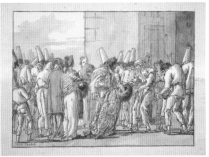

Punchinello's Father Brings Home His Bride, c. 1797. Pen and ink with wash on paper, 14 × 18¹³⁄₁₆ in (35.6 × 47.8 cm)

Here are two of the more than 100 drawings that the artist made on the theme of Punchinello. The inscription in the frontispiece means "An entertainment for children."

Tone as Structure

Tone is the property of relative lightness or darkness of an object. In painting and drawing, tonal values can be used for a variety of purposes:

- To distinguish between elements

- To create form and secure the illusion of consistent light throughout a painting or drawing

- The artist creates a range of tones from light to dark that correspond to the range that is displayed in the subject matter. As long as the tones in the painting are established in the same order as they are in the subject, then the illusion will work.

- For expressive effect. Caravaggio (1571–1610) was probably the first artist to fully exploit the theatrical qualities of tonal rendering. Rembrandt (1606–1669) often dramatically illuminated key elements within a painting, as did Velázquez (1599–1660), Eugène Delacroix (1798–1863), and many others.

Georges Seurat (1859–1891)
The Artist's Mother, 1882–1883. Conté
crayon on laid paper, 12 × 9³⁄₁₆ in (30.5 × 23.3 cm)

The artist builds a drawing that is entirely tonal—no lines are used at all. This is an example of the suggestive power of tone.

Touch Communicates

Many artworks present traces of the physical touch of the artist in the form of brushstrokes, fingermarks, chisel marks, and so forth. The nature of the marks made by an artist establish a bond with the viewer and provide a conduit for expression. The viewer empathizes with the kind of stroke made and understands immediately whether it is firm, angry, tender, delicate, rough, strident, or forceful. Similarly, in some sculpture, the touch of the artist is revealed as clay is pushed around or stone surfaces are carved and chiseled.

The communication of this almost biological information about the artist comes to the fore in much expressionist art, where the marks made often appear to carry a sense of the artist's state of mind. Qualities of urgency, obsession, frenetic energy, and exquisite delicacy, for instance, can be conveyed by touch.

Frans Hals (c.1580–1666)
Portrait of a Member of the Haarlem Civic Guard,
c. 1636-1638.
Oil on canvas,
33⅞ × 27³⁄₁₆ in
(86 × 69 cm)

Vincent van Gogh
(1853–1890)
The Olive Orchard
(Detail), 1889.
Oil on canvas,
28¾ × 36¼ in
(73 × 92.1 cm)

Hals's sure touch brings a warmth to the image. The energetic, speedy, and intense quality of Van Gogh's attack is revealed in his heavy and luscious touch.

Tribal Art

"Tribal" art refers to art made by people living in communities cut off from, or only recently acquainted with, the international community. These cultures are nonliterate, generally organized into small villages, and subsistent on hunting and gathering along with small-scale agriculture.

Most tribal art is integrated into ritualistic practices or otherwise forms a ceremonial role within the community. Anthropologist Alfred Gell suggests that many tribal artifacts have a "magical utility," in which their form and decoration assist with some important task. The decoration on a spear, for instance, may help it to its target. Without knowing this cultural context, an outsider may be hard-pressed to understand the nature of the artifact. Conversely, other authorities contend that tribal art is readily accessible and that qualities such as rhythm, balance, coloration, and strength are valued as they are in Western art.

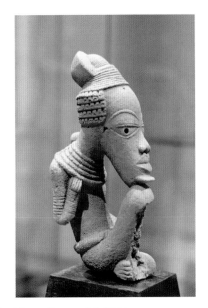

Figure with chin resting on his knee,
Nok sculpture, Nigeria, c. 6th century BCE.
Terra cotta, 14 in (35.6 cm) high

*The very large amount of tribal art that represents the human
figure, or heads, forms a simple, direct connection with all
humans.*

Trompe l'oeil

Trompe l'oeil is the attempt to deceive the viewer's eye into believing that a representation is actually the thing itself. This ambition for perfect imitation goes back to Greek art. Aristotle, in *The Poetics*, writes; ". . . universal is the pleasure felt in things imitated."

Since the mastery of representational techniques achieved in the Renaissance, trompe l'oeil has made regular appearances.

- **Architectural.** Mural and ceiling paintings attempt to convince the viewer that nonexistent spaces and architectural adornments are present.
- **Easel painting.** This creates the illusion that elements are projecting out in front of the picture plane.
- **Diversion.** An element is used as an amusing or diverting addition to another work of art. A highly realistic fly, for instance, might be painted on top of a picture or even on the frame.

Andrea Pozzo (1642–1709)
Fresco, Jesuit Church,
Vienna, 1703.

William Michael Harnett
(1848–1892)
The Old Violin, 1886.
Oil on canvas,
38 × 23 ⅝ in (96.5 × 60 cm)

Pozzo's dome is a painted illusion that works perfectly only from one point of view. Harnett's still life presents objects that appear to be projected into real space.

Underpainting

Underpainting is a technique that allows for the creation of greater depth and solidity in a painting. Although there are many variations, the most common procedure is to execute a monochrome version of an image, usually in a warm brown. Another popular option is simply to use black and white, a procedure known as grisaille. The underpainting may be worked until it is a fairly full account of the image and then allowed to dry. The artist will then build on top of it using glazes, semitransparent layers of paint, or stippled brushing so that the presence of the underpainting layer is at least partially visible through the succeeding layers. As the paint builds, the artist manipulates the color and interaction between the upper and lower layers, creating both an increased sense of depth and added richness of color.

See also Form Rendered • Layers

Nanette Fluhr
(1965–)
Demonstration,
Oil on canvas.
4½ × 6 in
(11.4 × 15.2 cm)

Studio of Peter Paul Rubens
Peter Paul Rubens, c. 1620.
Oil on Panel.
16¼ × 13¼ in
(41.3 × 33.7 cm)

Rubens and his studio used a warm brown underpainting sitting in the shadows. Here, this is still visible throughout this loosely rendered portrait.

Video Art

Video art is a genre that came into being in the late 1960s, when consumer portable video cameras were first manufactured. The form is distinguished from film and television by its lack of adherence to traditional expectations of entertainment and diversion.

STRATEGIES
- **Real time.** Video makes long takes possible. The idea of showing something in real time, however tedious, promises the possibility of viewing an unedited world.

- **Multiple display.** By 1969, new technology allowed for the screening of coordinated videos on multiple screens, a technique that is now commonplace.

- **Abstract.** Electronic synthesizers and digital graphic software allow for the creation of video images without the use of a camera.

- **Combination.** Video art can be combined with installation art or with traditional media.

See also Installation

Nam June Paik (1932–2006)
Self-Portrait, c. 1982. Video installation with sculpture

A bronze cast of the artist's face contemplates its own image streamed to a TV screen from a camera in front of it.

Credits